The Bikeriders

For Hugh Edwards

The Bikeriders

by DANNY LYON

aperture

This is a facsimile of *The Bikeriders*, which was originally published in 1968 by The Macmillan Company. The duotones in the 2014 Aperture edition were made by Robert J. Hennessey from original gelatin-silver prints by Chuck Kelton, working closely with the author.

Project Editor: Samantha Marlow
Typesetter: Sophie Butcher
Production: Sue Medlicott
Senior Text Editor: Susan Ciccotti
Proofreader: Brian Sholis
Work Scholars: Alison Karasyk, Jessica Lancaster, and Robyn Taylor

The staff of the Aperture book program includes:
Chris Boot, *Executive Director*; Lesley A. Martin, *Creative Director*; Taia Kwinter, *Publishing Manager*; Emily Patten, *Publishing Assistant*; Elena Goukassian, *Proofreader/Copy Editor*; True Sims, *Senior Production Manager*; Andrea Chlad, *Production Manager*; Brian Berding, *Designer*; Kellie McLaughlin, *Director of Sales and Marketing*; Richard Gregg, *Sales Director, Books*

First Aperture edition, 2014
Printed in China
10 9 8 7 6 5 4

Library of Congress Control Number: 2013956758
ISBN 978-1-59711-264-2

To order Aperture books, or inquire about gift or group orders, contact:
+1 212.946.7154
orders@aperture.org

For information about Aperture trade distribution worldwide, visit:
aperture.org/distribution

aperture
Aperture Foundation
548 West 28th Street, 4th Floor
New York, NY 10001
aperture.org

Aperture, a not-for-profit foundation, connects the photo community and its audiences with the most inspiring work, the sharpest ideas, and with each other—in print, in person, and online.

CONTENTS

INTRODUCTION

THE MATERIAL in this book was collected between 1963 and 1967 in an attempt to record and glorify the life of the American bikerider. It is a personal record, dealing mostly with bikeriders whom I know and care for. If anything has guided this work beyond the facts of the worlds presented it is what I have come to believe is the spirit of the bikeriders: the spirit of the hand that twists open the throttle on the crackling engines of big bikes and rides them on racetracks or through traffic or, on occasion, into oblivion.

The first bikerider I knew was Frank Jenner, who entered the University of Chicago at eighteen with a broken arm and who in the shower looked something like an ex-bullfighter. By the time his arm healed, his BSA had arrived in a crate and soon Jenner was scrambling on the 130th Street track in Chicago. The track was dirt, with some nice ruts and jumps, and only one tree directly on the course and that had a mattress tied around it. A lot of us had bikes or would get them, but not everyone raced. That took a special machine, the time and ability to work on it, and then the guts to run it. Jenner's bike was a 350 cc BSA, making it too big to start with the 250 class and at a handicap starting against the last class, which was 500 cc's and up. What they used to do was put Jenner up by the railroad tracks a few hundred feet behind the starting line and let him run against the 250's. At the start Jenner would come roaring down the hill into and usually through the 250's going off in their wheely's. Eventually Jenner built a racing Harley-Davidson CH (900 cc's) in his ninth-floor dormitory room and consequently left school to devote himself to racing. He managed to support himself on winnings until an accident at a Holland, Michigan, track in 1963 left Frank with a broken back and leg. After a long spell in the hospital, Jenner went back to Rochester, New York, where he lives with his wife and son and climbs trees for the Department of Parks.

The dirt track at 130th Street was and still is typical of scrambles tracks all over America. It was maintained by the Hot Sprockets M.C., a competition club affiliated with Ed Merkner's Triumph shop at 105th Street and South Torrence. Ed raced, as did his brother. His father, Dadio Merkner, was flag man, and Ed's mother sold tickets ($1.00) for the passengers in the cars and for bikeriders who came to watch. Some of the best scrambles there and at other tracks in the area were battles between Merkner and Johnny Goodpaster, who ran a BSA shop in Hobart, Indiana. Most of the spectators knew one another and the racers, which added something, particularly since soon the better riders would lap the field and the front and back of the line would merge into one continuous roaring circle of bikes bouncing over dirt hills and sliding around corners. Such tracks exist near every major city in America. If on a warm Sunday you see a trailored bike, or a small pack of bikes going down the highway, and you follow them, you'll probably end up at a scrambles track or a field meet. In fact if you pick up with the right people on the right day you might even end up at a blessing or a funeral.

Most of these weekend races and meets are sanctioned by the American Motorcycle Association. Membership in the AMA is required in order to participate in the events. The organization, whose motto is "Put Your Best Wheel Forward," urges its members, among other things, to be good citizens, obey all traffic laws, and use legal mufflers. The membership cards carry a quote by "famed head of the FBI" J. Edgar Hoover, reminding cyclists to be careful on the highway. There are and have been for many years, however, motorcycle clubs whose members are so far in spirit from attitudes of the AMA that they neither want nor could receive AMA sanction. These are known as outlaw clubs and it is not uncommon to see wives and girlfriends of members of outlaw clubs wearing the AMA patch in the middle of the seat of their pants. Although there is a real and widening division between the outlaw clubs and those participating in the sport of motorcycle racing, the groups and individuals involved often cross paths in the very close world of bikeriders. Jack Haferty, a motorcycle mechanic I originally knew through Jenner and who worked on and off at Merkner's, introduced me to his own motorcycle club, the Chicago Outlaws. I became a member of the Chicago Outlaws and rode with them during 1965 and 1966.

As one racer put it, "There's always been some bad apples around motorcycling." [1] The oldest remembered outlaw club in the Midwest is the McCook Outlaws, which existed in the late thirties and disbanded in 1947, when most of its surviving members became policemen in Chicago and its suburbs. In the early fifties the Chicago Outlaws Motorcycle Club was formed by bikeriders who had been meeting informally on the west side of the city. In 1958 the president of the club, who is now a motorcycle racer, tried to change the group into a competition club that would require its members to race occasionally. Opposition developed among the membership and the club split, half the riders going with Johnny Davis, a transit truck driver. Johnny retained the club colors and is still president of the Outlaws today. Meetings are held every Friday in various bars in Chicago and Cicero and weekend runs are scheduled, usually to the national championship races, often hundreds of miles from Chicago. The main attraction there is not the race, but the other outlaw clubs that arrive from all over the country to party with their friends. Recently in the Midwest a number of previously independent outlaw clubs formed a brotherhood with Chicago, causing them to drop their own colors and don a new patch similar to Chicago's. Thus the Milwaukee Outlaws (previously the Gypsy Outlaws) and the Louisville Outlaws, Columbus, Dayton, etc. Because of the trouble they sometimes cause around racetracks and the attention they inevitably attract to their activities, all outlaw clubs are at best considered a nuisance by most racers and by some a serious menace to all aspects of the sport of motorcycling.

The motorcycle world has been in a

[1] "They would ride in city or open country with their mufflers cut out, or in numerous cases absolutely devoid of muffling attachment. In some instances it was the rider's desire for noise, or to bring attention to the fact that he owned a motorcycle; in other instances it was the owner's desire for more power; but whichever the case, this offence in principle and in conjunction with that of unsuitable attire has done more to retard the advancement of motocycling in general than all other arguments combined."

Alfred H. Bastsch, "The Rise of the Motorcycle," *Harper's Weekly*, January, 1909.

state of continuous upheaval from the early sixties to the present. The introduction of small Japanese motorcycles to America, originally by Honda, has created an entirely new market for the machines, and consequently the use of all types of motorcycles, including the big bikes, has steadily increased year after year. In some states each year has seen a doubling in the number of registered bikes and with this increase a much broader base has developed for interest in motorcycles. The world of the bikerider that I originally encountered lies now entangled in new laws and the publicity of the press. If *The Wild Ones* were filmed today, Marlon Brando and the Black Rebel Motorcycle Club would all have to wear helmets. I used to be afraid that when Angels became movie stars and Cal the hero of a book, the bikerider would perish on the coffee tables of America. But now I think that this attention doesn't have the strength of reality of the people it aspires to know, and that as long as Harley-Davidsons are manufactured other bikeriders will appear, riding unknown and beautiful through Chicago, into the streets of Cicero.

RACES AND FIELD MEETS

Frank Jenner, La Porte, Indiana

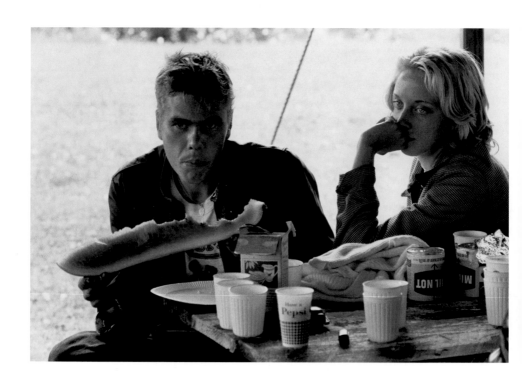

Ronnie and Cheri, La Porte, Indiana

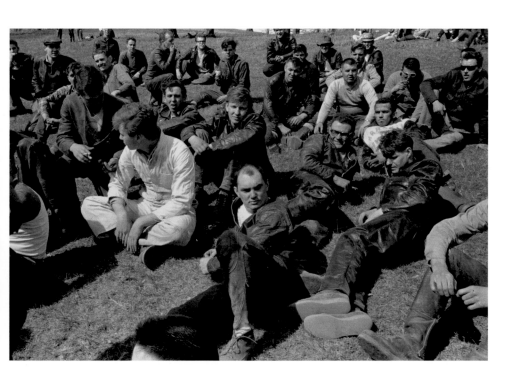

Riders' Meeting, Elkhorn, Wisconsin

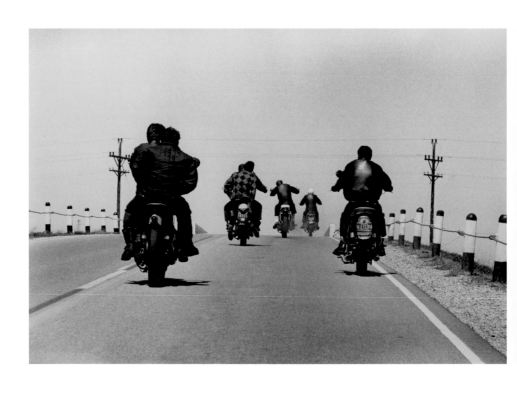

Route 12, Wisconsin

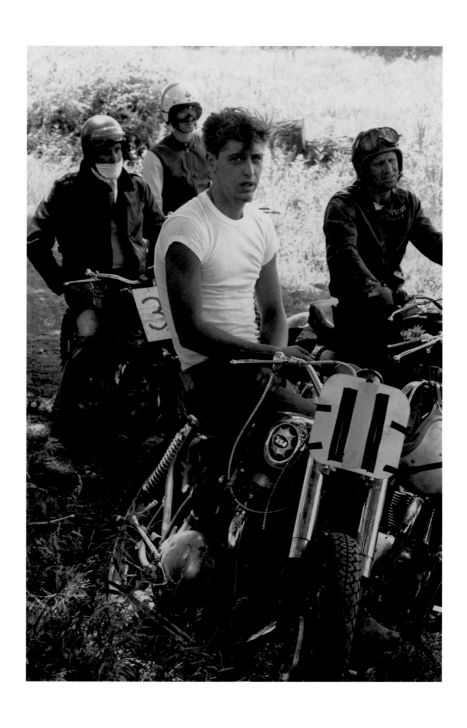

Racers, McHenry, Illinois

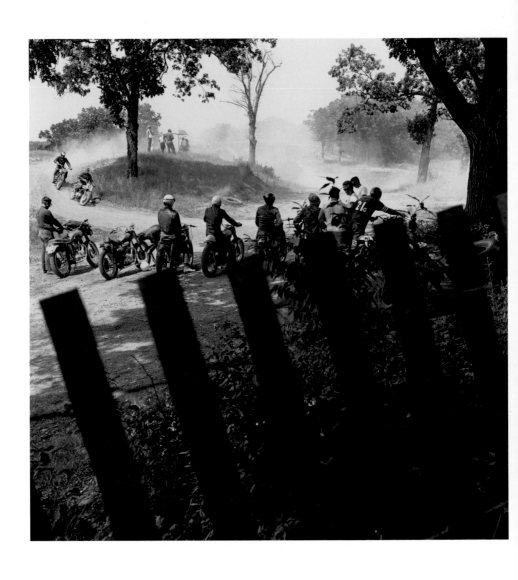

Scrambles track, McHenry, Illinois

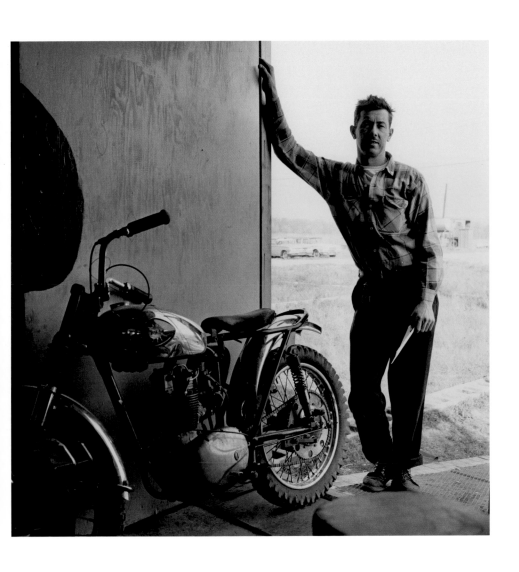

Johnny Goodpaster, Hobart, Indiana

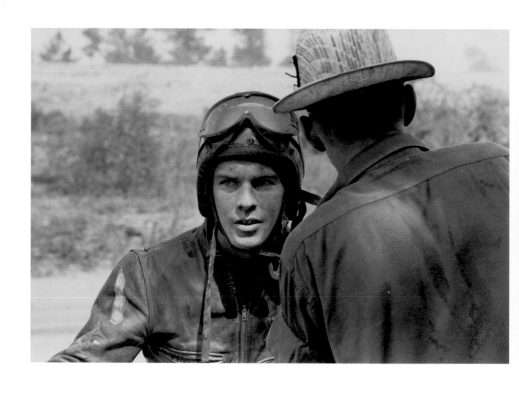

Racer, Griffin, Georgia

Field meet, Long Island, New York

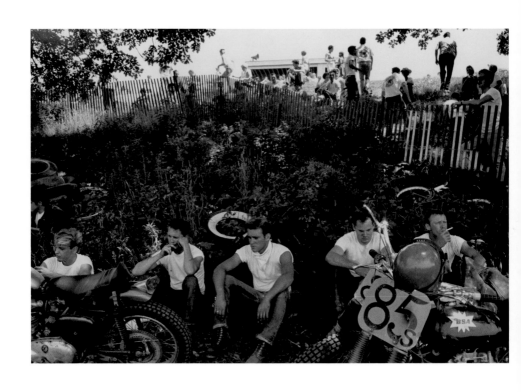

Racers, McHenry, Illinois

10

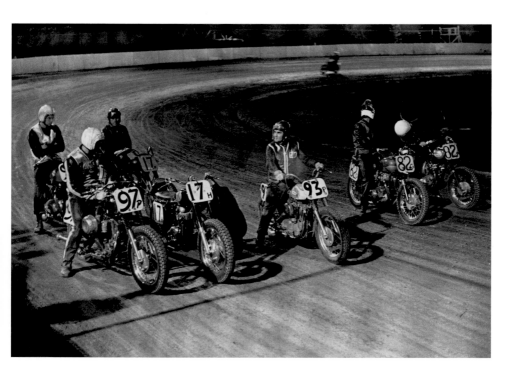

Santa Fe track, Chicago

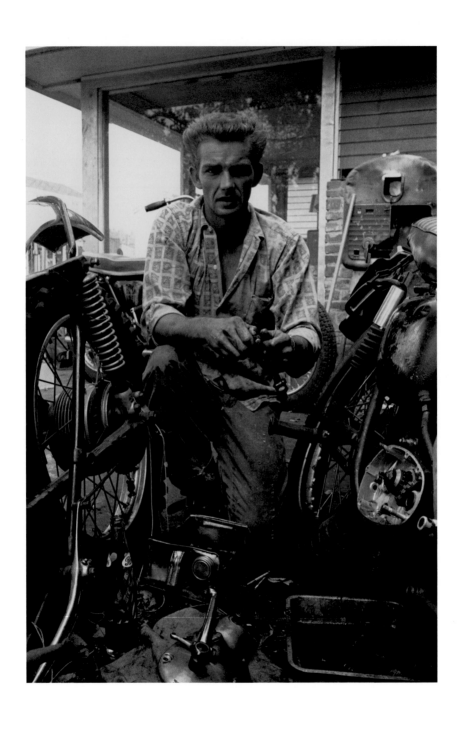

Broken gear box spring, New Orleans

Torello Tachhi's back, Loudon, New Hampshire

Gaucho field meet, Chicago

14

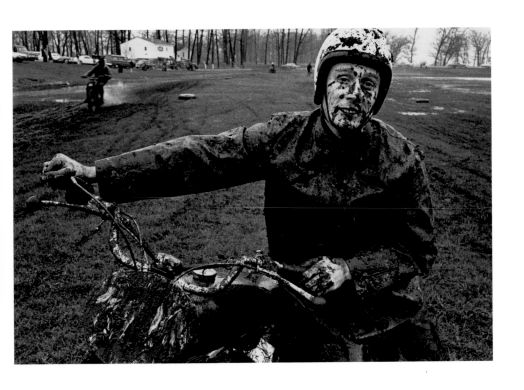

Racer, Schererville, Indiana

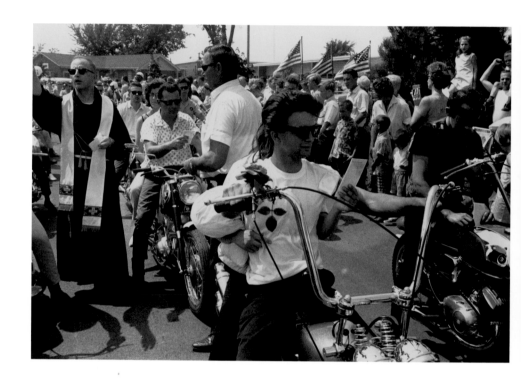

Seventeenth Annual World's Largest Motorcycle Blessing, St. Christopher Shrine, Midlothian, Illinois

16

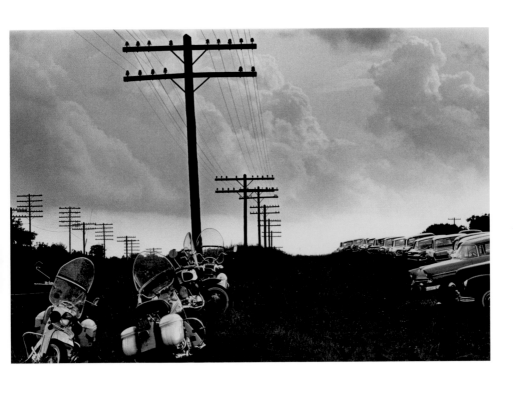

Route 90, Alabama

THE CHICAGO OUTLAW
MOTORCYCLE CLUB

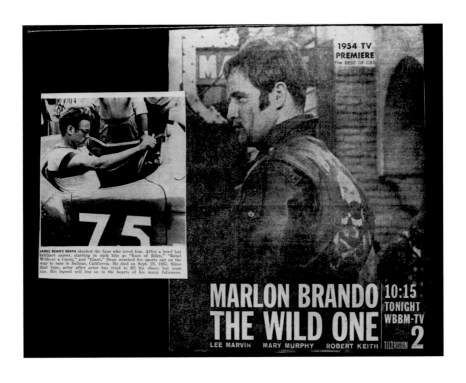

JAMES DEAN'S DEATH shocked the fans who loved him. After a brief but brilliant career, starring in such hits as "East of Eden," "Rebel Without a Cause," and "Giant," Dean wrecked his sports car on the way to race in Salinas, California. He died on Sept. 23, 1955. Since that time, actor after actor has tried to fill his shoes, but none can. His legend will live on in the hearts of his many followers.

1954 TV PREMIERE
The BEST OF CBS

MARLON BRANDO
THE WILD ONE
LEE MARVIN MARY MURPHY ROBERT KEITH
10:15 TONIGHT WBBM-TV 2 TELEVISION

Johnny Davis' scrapbook

19

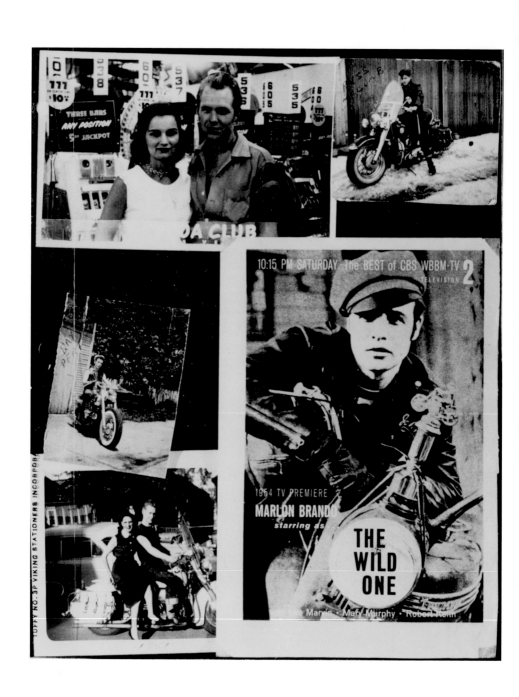

Johnny Davis' scrapbook

Chicago Outlaw Motorcycle Club

Gratefully acknowledging and thanking you for your kind expression of sympathy ———

My Jesus have mercy on the soul of

Alan Saunders

Born
JULY 9, 1943

Passed Away
JULY 26, 1964

†

O GENTLEST Heart of Jesus, ever present in the Blessed Sacrament, ever consumed with burning love for the poor captive souls in Purgatory have mercy on the soul of Thy departed servant. Be not severe in Thy judgment but let some drops of Thy Precious Blood fall upon the devouring flames, and do Thou O Merciful Savior send Thy angels to conduct Thy departed servant to a place of refreshment, light and peace.
—Amen.

May the souls of all the faithful departed through the mercy of God, rest in peace. Amen.

36 CHICAGO SUN-TIMES, Mon., Apr. 29

KILLED TEST-DRIVING CYCLE

Dan Hammond (left), 20, and Richard Hoffmann, 18, remove crushed motorcycle from alley behind 4338 W. Cortez after fatal accident. Robert A. Burtz, 21, of Palatine was test-driving the cycle prior to possible purchase when it went out of control and smashed into the utility pole. He was killed. (Sun-Times Photo)

2 Motorcycles Collide; 1 Killed

One motorcyclist was killed and another seriously injured Sunday when their vehicles collided on Wille near Mount Prospect Rd. in Des Plaines.

Killed was Alan R. Saunders, 21, of 8218 Oconto, Niles. Terry Oswald, 25, of 601 Wesley, Park Ridge, was reported in serious condition in Holy Family Hospital, Des Plaines, suffering from a broken leg and multiple lacerations.

Witnesses told the police that Saunders was traveling at a high rate of speed when his motorcycle sideswiped Oswald's vehicle. Saunders was thrown more than 100 feet and Oswald some 15 feet.

KEITH

1 Dead In Crash Involving Car, Truck, Cycle

One man was killed and two others were injured Friday in a collision involving a semi-trailer truck, an auto and a motorcycle near 2950 N. Western.

Dead was Robert W. Holzkampf, 21, of 1910 N. Keystone, driver of the car.

Treated at St. Elizabeth's Hospital were William Fraley, 23, of 1714 N. Humboldt, a passenger in the auto, and Alvin Chase, 24, of 5611 W. Fulton, who was driving the motorcycle. Fraley suffered lacerations and abrasions and Chase a dislocated shoulder.

The driver of the truck, Leo DiPompeo, 42, of 4816 W. 23d, Cicero, was uninjured.

Traffic Area 5 police said Holzkampf's auto was southbound on Western when it skidded into the rear of DiPompeo's tractor, which was standing still waiting for the light to change at Diversey. The auto then struck the motorcycle, police said.

Raymor

Johnny Davis' scrapbook

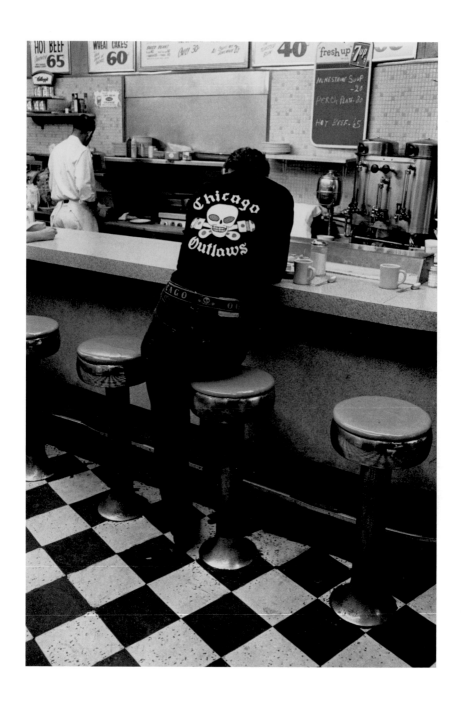

Jack, Chicago

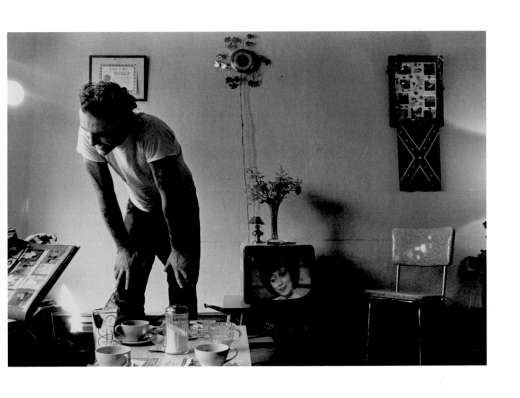

Corky at home, Chicago

23

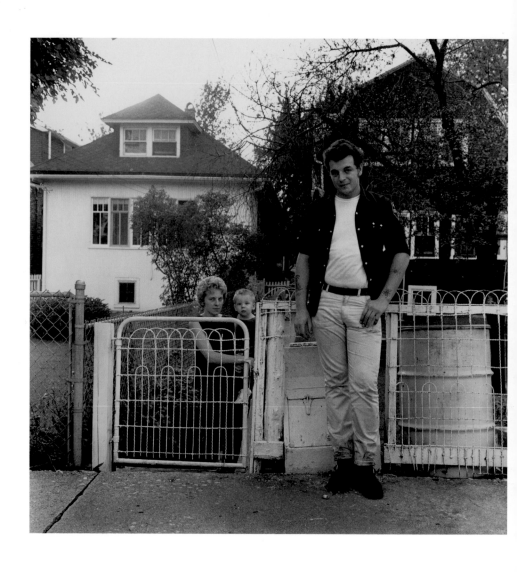

Cockroach and his family, Chicago

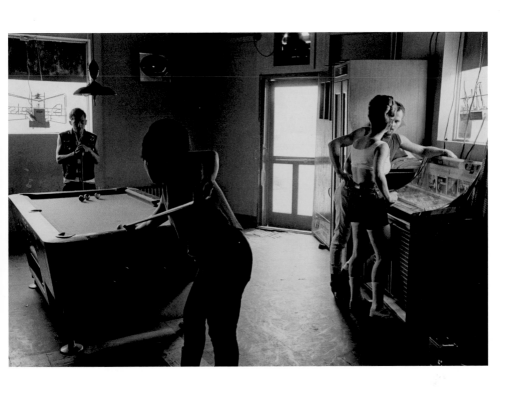

New York Eddie's, Chicago

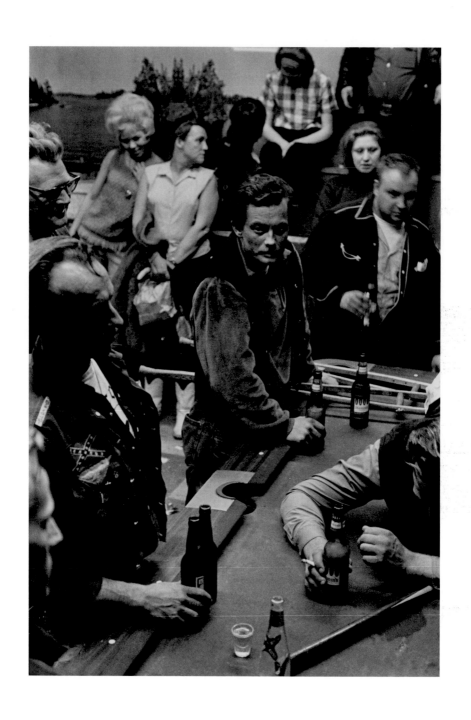

Andy, meeting at the Stoplight, Cicero, Illinois

26

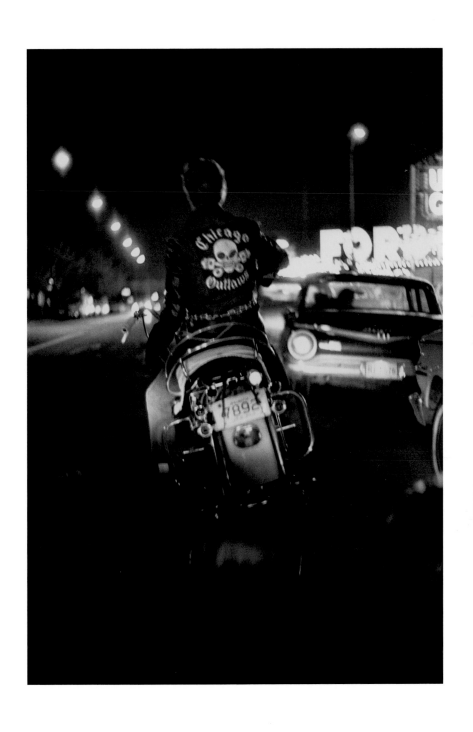

Benny, Grand and Division, Chicago

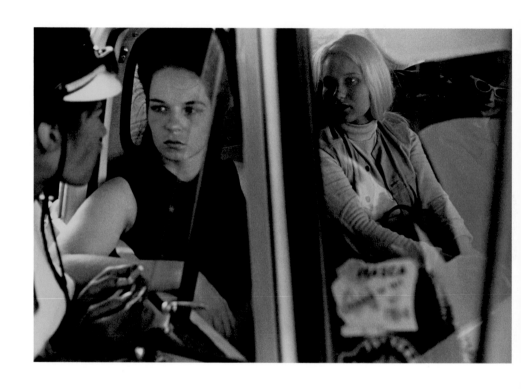

Outlaw women, Starved Rock picnic, Illinois

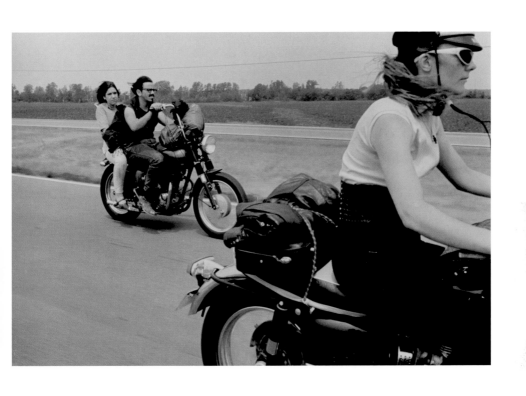

From Dayton to Columbus, Ohio

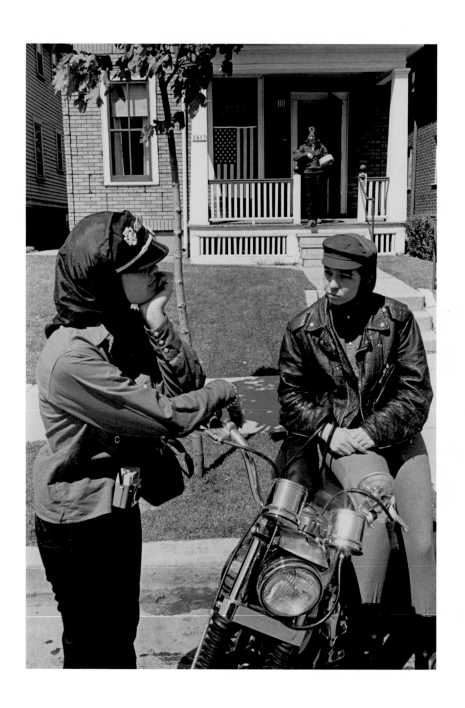

Memorial Day run, Milwaukee

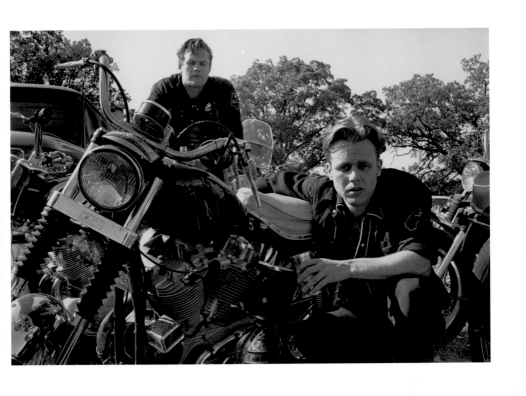

Brucie, his CH, and Crazy Charlie, McHenry, Illinois

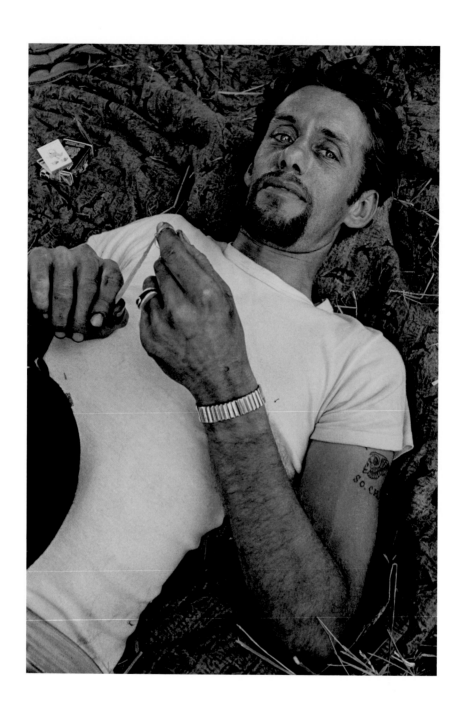

Cal, Springfield, Illinois

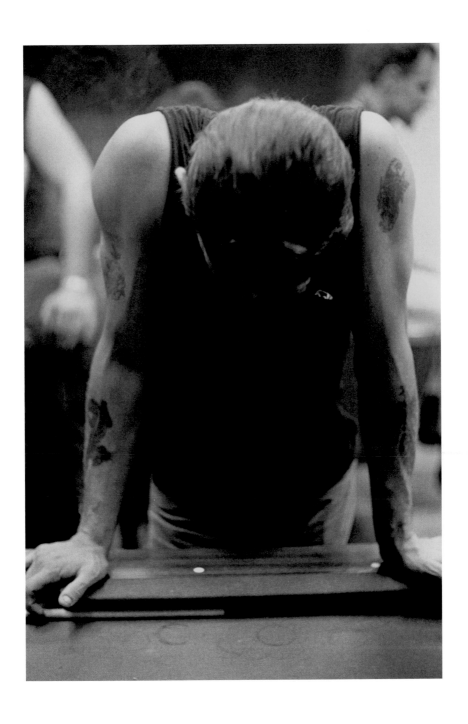

Benny at the Stoplight, Cicero, Illinois

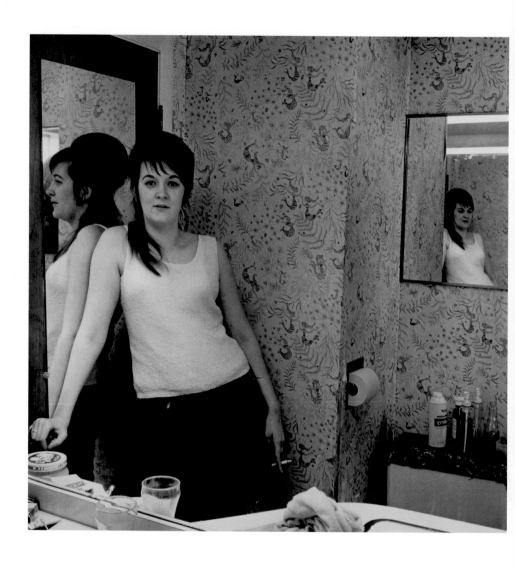

Kathy, Chicago

34

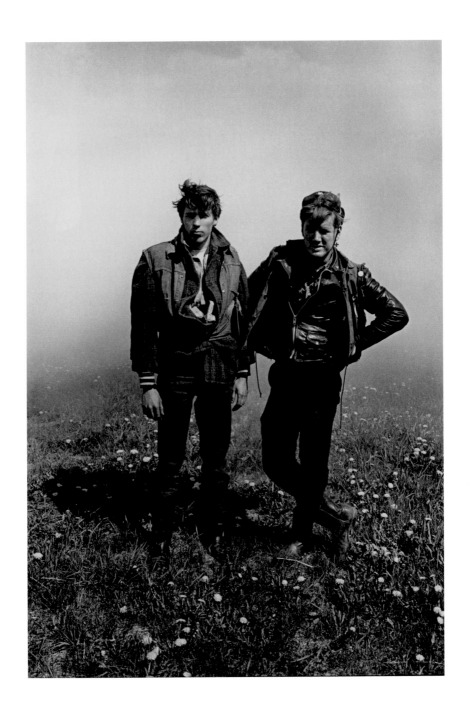

Dave and Rawhide (Columbus Outlaws), Elkhorn, Wisconsin

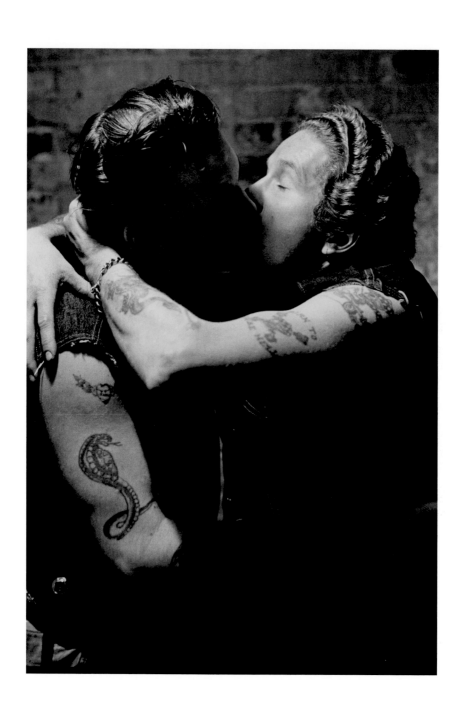

Corky and Funny Sonny, Chicago

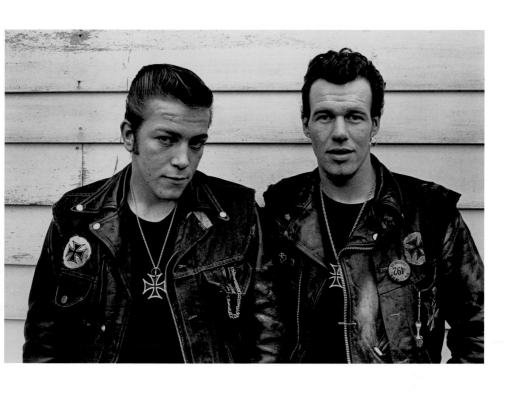

Sparky and Cowboy (Gary Rogues), Schererville, Indiana

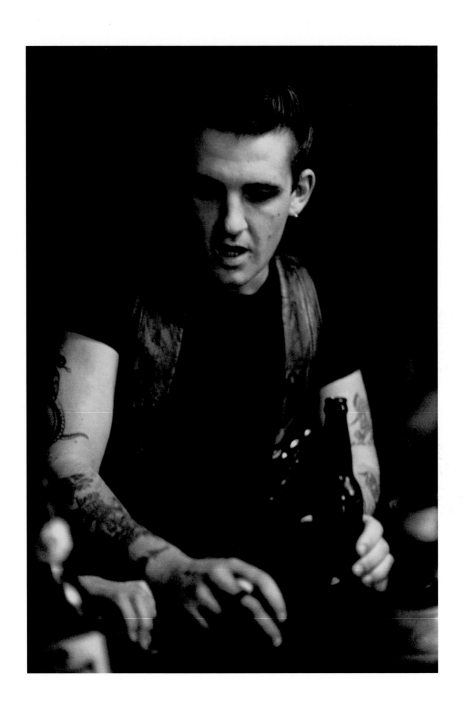

Corky at an Apache dance, Chicago

38

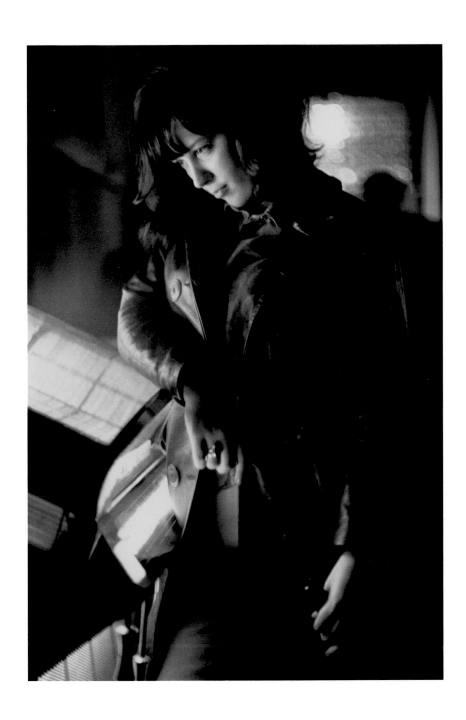

Big Barbara, Chicago

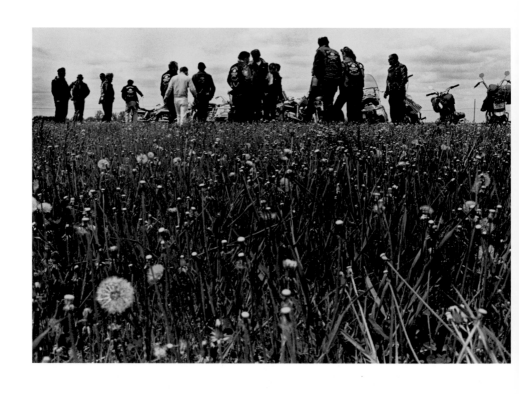

Outlaw camp, Elkhorn, Wisconsin

40

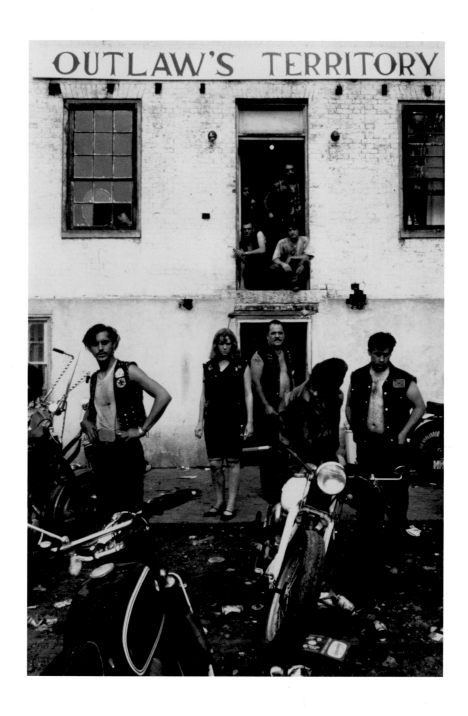

Club house during the Columbus run, Dayton, Ohio

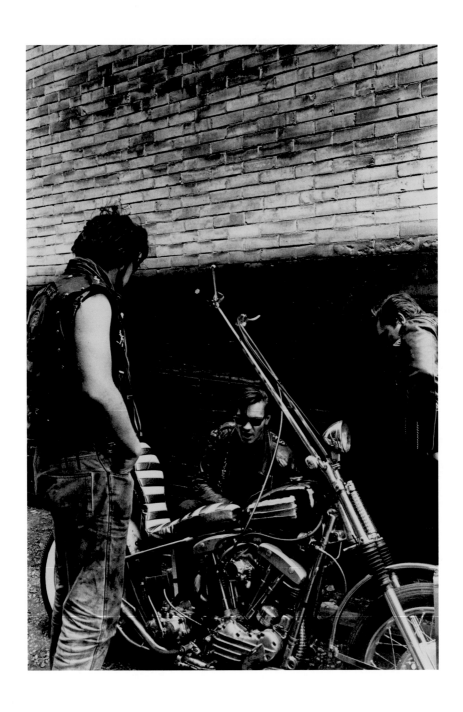

Chopper, Milwaukee

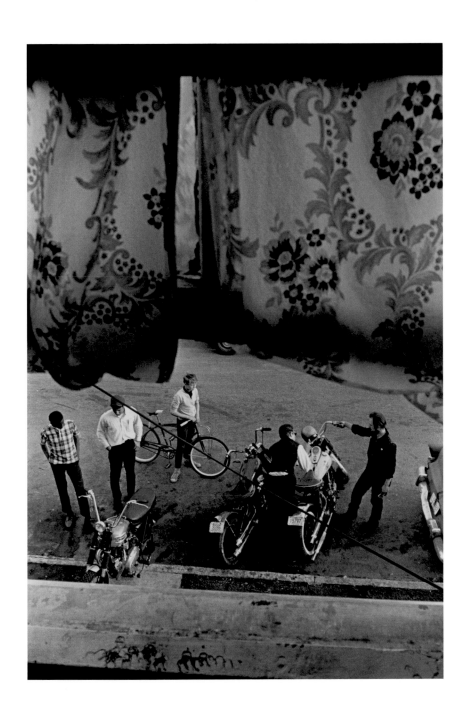

From Lindsey's room, Louisville

43

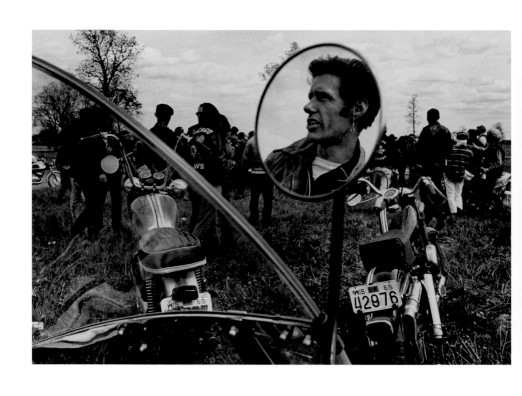

Cal, Elkhorn, Wisconsin

44

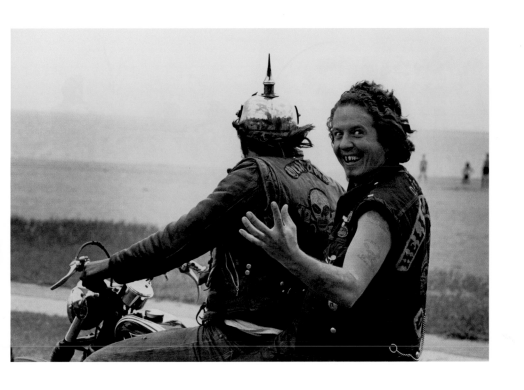

Funny Sonny packing with Zipco, Milwaukee

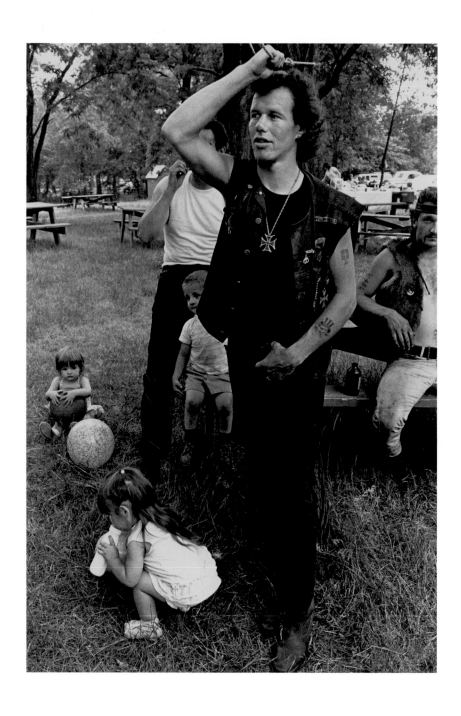

Cowboy at a Rogues' picnic, South Chicago

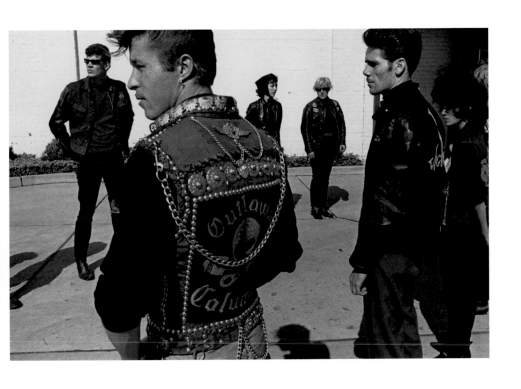

Renegade's funeral, Detroit

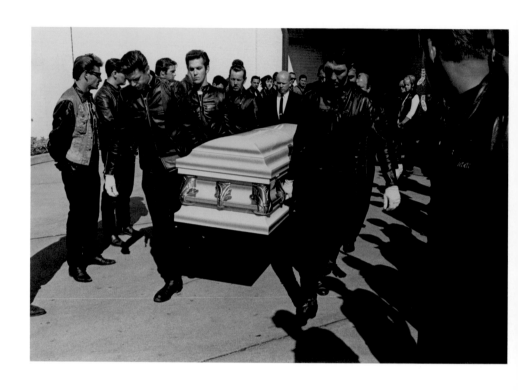

Renegade's funeral, Detroit

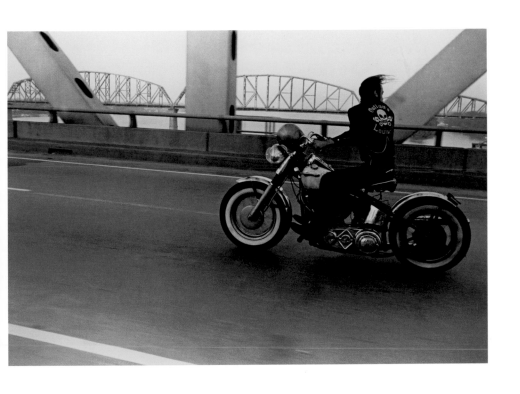

Crossing the Ohio, Louisville

49

TEXT

ARMY

CAL Age Twenty-eight. Ex-Hell's Angel. Member, Chicago Outlaws

See, I was born in Canada originally, you hip to it? And then I went up to the fourth grade. The fourth grade, man, in school, in French, no English. I come to the United States and they put me in with all those dudes that speak English and I'm hassling it myself, just tryin' to learn the language. Let alone read fourth-grade books. So it was that way with me all the way up to high school.

Like when I was getting up into high school I could never catch up with the people, see. My brothers had a better chance to do that. But I couldn't read a goddam comic book, man, until I was in almost seventh grade. So anyhow, I joined the service, see, later on. And I got a undesirable discharge in there, too, because I was always salty. But since I was in the service, I learned how to read. I can read and write. I can read any hand-book I want now. I got more education than really a lot of people because I've been to eighteen different countries. I've seen what most people have read about. Like anyplace man—I went to Hawaii, Australia, and I went to Spain, Morocco, England, Germany, I went to Italy. I was there for just a few hours though and like take the United States, man, I've traveled it back and forth, man, about fifteen or twenty times. Not only from Los Angeles to New York, man, but from Oregon to Florida. You know, just anyplace I'd de-

cide to trip to. And I've seen what people are reading about. So therefore I figure I've got more knowledge up here stored up than half the college kids my age, still going to college. Sure, they know plenty. I mean, they know all about it, but they actually never experienced or seen it.

When I left high school I joined the service. I was about seventeen. That was in '55. In the meantime I lost a couple of grades, you know, failing and all this jazz. I just couldn't help it, man. When I got in high school it was a different story than junior high. More garbage to learn and I didn't know how to read yet. So I went in the service, man, and I took a little reading course, you know, and I had to write all kinds a ticket books out, man, and I couldn't even write. Like if you're from Pennsylvania I would say to myself how the fuck do you spell Pennsylvania? And I just put Pa., you know, period. I'd abbreviate anything. Are you hip to it? And I made rank real fast, man, by being salty. I got my basic training and then they ship me off, they figure I'm best suited for air police work, you know? So they shoot me to air police school, so I learn how to be an air policeman, *zip zip*. And the training and all that garbage, you know. Then they shipped me into Tampa, Florida. O.K., I'm in Tampa, Florida, man, about three or four days and I just reported in and everything. Anyhow, they

put me on a post, you know, and it's the main gate. First night. So in comes the base commander, the boss, and he's in civilian clothes, smashed out of his cap, no ID on him or nothing. So I figured it's just a drunk tryin' to crash the gate. And this guy's cold stoned. So I pulls him out of his car, man, out of the taxi. And I put him in this little room we have. And I have him strip right down to his shorts and socks. And I gather up all his shit and I throw it over in the corner 'cause, you know, they're all wrinkled up anyway. With a drunk there's only one way to handle 'em.

So I tell him to sit down and I call my CO up, Commanding Officer. Anyhow, I says, I got a drunk over here at the main gate. I want you to bring him to the brig, see. And he comes out and he blows his cap 'cause he knows who he is. I don't know. To me he's just a drunk. So he tells me to report to my quarters, you know, have a good night's sleep and come in the office tomorrow, see. So I do this, you know, I get in class-A uniform and all sharp and all this stuff. I goes over there and my CO tells me to go and see the base commander, such and such address and everything, in his office. So I go on there and knock on the door. He says, come in. So he's sitting at a chair like this, man, and he's lookin' out the window. You know, and I can't see his face and I come up to his desk. I said, Third Class Davis reporting as ordered, sir. I'm standing at attention, and he turns around, see, he's gotta return my salute. I'm standing at rigid attention for about five minutes, see. He's blowin' my cap is what he's doing. So he turns around, man, and I'm standing there like this. Just like this, man, rigid, and I've been standing this way for a long time now. And he turns around and I see who the fuck it is, I'm blowin' my cap

now. I got all these visions of jail, penitentiary, banging shit. 'Cause you're scared, boy, when you're a kid. You know what I mean? This guy's the big cheese, he's got birds up here and all this shit. And so he returns my salute and he says —he's still blowin' my cap cause I don't know what the fuck's happening. So he reaches over, man, he congratulates me on doing a good job last night at the main gate. That's the way it shoulda been done. An' also, man, he gave me a second stripe, see. Now usually you have to wait almost a whole year, after you report, to get a second stripe. So now I got two stripes, so now I'm bigheaded. Big bad cop. I got little ducks running around under me now, see, and I'm climbing the ladder. And so I go overseas to Morocco and I spend a little hitch over there, about six or seven months, and when it came time, you know, it's time and grade. When you got enough time in, a year, you're eligible for a stripe. So anyhow, I makes my Airman First Class. I got three stripes now and I've only been in a little over a year, man. I'm getting a big head, see. So anyhow, this guy, the base commander, it comes back to him now, I'm Airman First Class. We meet again, in other words. And he asks me, man, if I would drive his car around for him—that's all I had to do. And be in my little white cap, you know, and we had the boots, man, we tucked our pants in, up here, you know. All boots with white shoelaces, white fuckin' silk scarf, and blue. It looks beautiful, you know. Like an honor guard, that's what we looked like. Like honor guards, man. So I drive his car, man, wherever he wanted to go. You know, like if he wanted to trip up to Georgia I drove his car up, him in the back. Or take him up to the airport downtown if he went to see his family or something. And that's all

I had to do. So therefore I earned a fourth stripe, see. When he made general. Anyhow, when he made general he went to Washington and so he didn't have no more use for me. And I'd been livin' soft, man, for about seven months, partying. When the base goes on alert, I just say, say man, can I just go to town and see my girl tonight? He says, sure man. He'd write me out a little piece of paper, "this man's on official business." I take his fuckin' car, man, and I'd trip over to my girl. I got married there. But anyhow, when he made general I had four stripes, see. And they put me out in the fuckin' boondocks, with an M-1, you know, an' I'm roughing it now. I'm guardin' this little fuckin' gate, way out, man, near the flight field. And this colonel, he came to this gate on a six-ton, on this big truck, with a bunch of people on it. Flyers, they got all their fuckin' parachutes. They're coming back off a mission—in other words, see, they gotta come through my gate. And so, we got all these little passes, you know, with our pictures on it. So this lieutenant and this lieutenant colonel switched, to see if I'd catch it, you know? And so I caught 'em. So I handed the lieutenant, the little beginner, back his pass, and I say, colonel, would you step off the truck, please. And that made him salty, see, because I sent the truck on. I told the truck to split. I'm gonna check on him, right? See, and I sent the truck on. It's a quarter of a mile from my post to the hangar and he's got to walk with all his parachutes and garbage, his little bag, you know. That's heavy, you know. He's pissed off. And this is a lieutenant colonel, man, next one is general. See? And I'm fuckin' over him and I've only got four stripes. And so he's salty. I got off the truck first and I'm standing port arms because when you got an M-1—you know, with the weapon this

way. So I got my weapon like this and my partner over here said something to me and this guy's gettin' off the truck in the meantime. I turned my head to see what he had to say, wasn't important, you know. And I came back like this and I look and this guy had already gotten off the truck and he was gonna reach for my weapon. In other words, I come back and here this guy's reaching for my weapon. I steps back like this, man, and I hit him in the chin, right here, jammed the butt right in his chest, like that. It was a nice, beautiful spot, see. So anyhow, he's on the ground, bleeding like a motherfucker. See, I'm pissed off 'cause he tried to grab my weapon, you know, and he's mumbling something, you know. And when you're on post and it's peacetime, see, there's eight rounds to a clip. And you take one of the rounds out and put it in your pocket and you can slide that bolt forward and nothing will be in the chamber, see. That's how you're on post. Your weapon is still loaded, but there's nothing in the chamber. See, in combat you would just go like that and you would inject the shell and it would be a loaded weapon. Anyhow, while he's sniveling down there, I'm salty, see, I just put the weapon right down on his nose and I injected a shell into the chamber, I got one in the chamber now. And I said, you move, you dirty motherfucker, and I'll blow your cap off. You know what I mean? And I'm steppin' on his fuckin' one of his arms, right here, you hip to it? And he's all fucked up 'cause I broke his jaw in five places and broke three of his ribs. That's how much damage I did to him, how salty I got. You know what I mean? But I blow up that way, see. Anyhow, when it came down to the court scene, see, my trial, well, hittin' him I was in the line of duty. They couldn't bust me for that or do anything to me for

that. You know what they give me an undesirable discharge on? Callin' him a motherfucker. Are you hip to that? That's what they did, that's what they discharged me on. See, when I injected that shell I says, you move, you dirty motherfucker, and I'll blow your cap off. You know, that's what they busted me on, kicked me out of the service.

They give me a lawyer, but he's brass, too, and all the brass stick together. See, they didn't like me for one thing—I was an agitator all the time. Like they give me a ticket book, you know, to go out and write tickets. I'm supposed to go out and write so many tickets, I would go out to the officers' quarters and I'd just write 'em up for anything, see. All the officers. I wouldn't give anybody with a stripe a ticket. Even if they're goin' a hundred miles an hour on base. I wouldn't give him a ticket. I'd give him a break. So anyhow, they didn't like me because when that ticket book came in, everybody had a summons and they had to report to my CO for punishment. He was like a judge, too. When all these officers would be comin' in they got more rank than him, 'cause he was only a captain. And they got, you know, full birds and generals. I'd write 'em up for anything, man. Park your scooter crooked, you know, like the little motor scooters. You weren't in the lines and all that. A lot of weird chicken shit stuff. Just fill up the book. They didn't like me. 'Cause all them fuckin' officers there, they'd pull rank, you know. O.K., you fuck over me on this little ticket, you wait, you gotta come in front of me sometime, you hip to it? All of 'em do that, see. They got more rank than you. And so my CO was gettin', you know, this was blowin' his cap, he wants to get rid of me, too. So when all this happened, the officers, they were all glad.

DRAFT BOARD

ZIPCO Age Twenty-three. Member, Milwaukee Outlaws

Wintertime when this fuckin' shrimp boat wasn't catchin' nothing I was almost starvin' down there. So I decided to come back. I was seventeen and a half. Seventeen, I come back. I went to school, man, I went all the way to eleventh grade. And I'd take off, you know, and come back, and take off. When JB was there I stayed down there the longest that time. Then the fuckin' draft board's gettin' on my ass all the time. The draft board, you know? They're sendin' letters to my ma and every time I go I have to change my draft board down in Texas. And I was down there and then we moved up to Louisiana—the boat went up there for a while. And they send me a letter I gotta be at the draft board in Texas. So I get off my boat and I make it down there and I'm too late. Fucked up again. And this other time, I was in Galveston—I had a setup for Louisiana, you know? And the fuckers throw me in the

goddam Galveston clink. I quit my job on the boat. I was goin' for the draft. I was goin' to go. I got all drunked up. Went to the bus station, got my ticket and I just conked out in the bus station. And the cops threw me in the fuckin' clink for drunk. And I said, I gotta be there, certain time, you know? And the motherfuckers kept me in so late I missed it. Then later I come back up here this last time, you know? To join the army. That's why I left down there. Cause I was makin' some money down there, we were really catchin' the shrimp that time, not this summer, last summer. Man, I was makin' 300 bucks a week. I was really rollin' it in. I was so fucked up, drunk. I was makin' $350, $400. One month I made a thousand dollars, man, and I'd just throw it away. I went nuts when I got drunk, you know? Everything's whoomp, fuck it. 'Cause I thought I was goin' in the army, 'cause this last check was almost $500. My last check before I was going in the army and I wanted to go. I always wanted to be—go over there to Vietnam. And I comes back here and those motherfuckers, they got a big party at the Seaway there, where I went the night before. And I get home about four, you know, and my ma comes home. You ain't goin' yet. My alarm clock's ringin'. It's electric, you know? I'm still conked out. Fuckin' beard full of wine. And my ma takes me in a taxicab, drives me over there, throws me in there. You know, they go from station to station, you sit down. I keep fallin' asleep. Smelled like a distillery. Hey, I passed all the fuckin' tests, man. And I walks out of there, the guy says, hey, you flunked your physical. I says, what the fuck? What? My ears? I couldn't hear or what? And he says, no, your psychiatrist flunked you. What? What? He says you're a schizophrenic personality. Some shit like that,

you know. Smelled like a fuckin' distillery, wined up. I give him good answers, you know? So he says I passed everything except, he says, you're an undesirable character, we don't want you. I says, I wanna go, you know? And I cussed that fucker out that told me that. You goddam motherfuckin' bastard, cocksucker, I walked outta there. I was cryin' for a day, I wanted to go. And I went home and cried. No shit. I bought two barrels of beer at the Seaway the night before. For the boys. Before I went. I ain't shittin' you, hey. What do you think of that crap? And there's pinkos burnin' their draft cards they that wanno go they won't take, you know? Boy, that pissed me off. I wanted to go to the marines, but I couldn't go. I was an alien. And I had a record. But I could make it in the army. I went to join the marines before I went down to the draft board deal. And they says you're an alien and you got a record, you can't go. If you just had a record we'd let you in or if you was just an alien without a record we'd let you in. But two you can't have. No DP fucker they don't want. DP. I'm a DP. I was born in Latvia. Across the sea. Come on a boat in '51. I was seven. Seven years old. I went to Iowa. Grow corn and raise pigs. Me and my mom, and my brother came. My old man came in about '57. He's cool. I always thought he was a prick an' everything cause he'd never work, you know. My ma has been workin', always workin' to support me and my brother. And the old man's always been sick or something. And then when he come to America he was allright. Worked for a little bit and then he'd lay off, fuck it, let the old lady work. Hey, they was workin' in the same place. My ma got him a job. And the whole company folded up, it was a bakery. And the old man, he went down

to unemployment, stand in line with the niggers, get that check every month. Ma went and got a job, you know? He's still standin', about five months now. My ma's been working. Hey, he's cool though. I think the same way. Let them fuckin' cunts work. They want to work, let 'em work. He's a photographer. He learned that when he had TB. He used to have TB. That's why he couldn't come here. So he learned that down there in Germany. He got two big enlargers. He's got a Leica, real expensive one. Lotta money in it, you know? All the lenses and all that shit. Got two Rolleiflexes, he's got one of those newspaper photographer cameras and he's got one of those big old box portrait jobs. Got a whole bunch of those stands. He's got one real big stand for portraits. A whole bunch of lights and shit. But he won't go in that fuckin' shit, you know. He's afraid. Oh, I can't talk, he says. He can talk even better than my ma. He was in the Latvian army when I was born and then he was in nothin'. 'Cause all the Latvian army actually got pushed over to the German army. 'Cause they hate the Russians more. Russia's right next to us, you know? First in, I don't know, '30-something, all the Russians come in and took over the country. Took all our leaders and took 'em to Siberia and killed 'em.

And the Germans chased 'em out. And all the people were real pissed off at the Russians so they joined up with the Germans. They wouldn't of joined up, you know, they didn't like 'em either, but they thought that the United States was gonna kick the Germans out anyway and they hated Russians more—what the hell they gonna do, you know? And if you didn't fight for them they'd fuck you up. So they were in with the Germans. Now my brother's in the Air Force, he's goin' to Thailand next November. Air Force mechanic. They took him in 'cause he was a clean-cut all-American boy. Short pants, tennis shoes. I like my brother, but the only thing I didn't like about him, he's a pinko. He fights good and everything, you know. But he hangs around with all these goddam pinkos all the time. Short pants and college fuckers all the time. And they drive you out of your mind. I told him. He went to college one year, half a year, not even half a year. He went about three months and I says, fucker, you don't quit that college I'll beat the shit out of you. You know? 'Cause, I says, I don't want no college pinko in my family. 'Cause I can't stand 'em. 'Cause if you can't work with your fuckin' hands you ain't no fuckin' good.

DRAG BIKE
CAL AND ZIPCO

Cal Michael was born in Los Angeles and Linda was born in Florida. Like my old lady and I hassled around Christmas, so she wanted to come home. So I said, you

want to go home? I'll send you. So I sent her home for Christmas and she was there almost a year. Before I showed up on the scene. It was something about seven or eight months and she was pregnant when she left. You know, and the kid was already born and everything when I got there. Like I wanted to see my little girl, so I got on my bike and went. So then I decided to hang it up in Florida for a little while, see. My old lady and I were making it together again. And I came to Florida on a bike. When I was married I got a bike and she talked me into getting rid of it. So when we split up for the first time, when I sent her home, I got me a bike. I got me a Triumph and dressed it all out and everything. Beautiful, beautiful chopper. Went back to Florida and I still had my bike. I was going back and forth to work on it and everything. I kept my bike, in other words, when we went back together. And so times were getting tough and so I just—I sold my bike to pay for shit for the house 'cause I wasn't working. Work is rotten in Florida. And so times were getting good again now. I got a good job and everything and I'm makin' out, I got coins in the bank, you know, and I say, well, honey, I think I'll trip down and get a bike. Some piece of junk that I can tinker with. So that's when my old lady says, you know, like, you ain't gettin' no bike. And if you get one it's all over again. The whole thing, you know. So I got salty about that, cause, see, I gave up my bike, man, I didn't have to give it up, man, she didn't tell me to get rid of it or anything. I gave it up 'cause we needed coins. And here we got coins again, well, I think I should have my bike. Right? Or else why should I have gotten rid of my first one, you know, the one in the beginning? So anyhow, she says I'm not gonna build a bike or even ride a bike no more, see. So

I goes out, man, I scrounges up these parts, you know, a frame, two frames. I started on the frame, two frames, you hip to it? I cut one front end off. She asks me what I'm doing? Oh, I'm just tinkering. I'm schemin'. My mind is turning. I start scheming on parts, man, like I got two frames, you know, and I cut the front off of one and I cut the back off the other and used the center post. See, I had to have two center posts 'cause I got two engines to tie up. You hip to it? The front and the back, I had both, you know, and when I got through building my frame I still had a front and a back but no center post. That's what I added, to build the twin engines. And then she thinks I'm just tinkerin' around. See? She don't know what I'm scheming on, I'm gonna build the biggest, the baddest motherfucker, and she says, you're not gonna build a bike. So I'm going completely zenith and going the other way. You know who lives down the street, by the way, while all this is going on? Don Garlits lives down the street. And he holds the world's record for the drag strip. He owns his own drag strip which is three-quarters of a mile from where we're at. This is on record, man, like he still owns it right now. Two hundred and nine miles, 216 miles an hour in the quarter mile, hey, that's—you know, I turn 158 man and that's past the 150 mark. That's flying like a motherfucker. You can imagine what it is around 200. And you know, like it's like *shoooo*, like that, man, and when you get on the end you don't like keep going and slow down. You gotta stop that motherfucker. People don't realize that. You gotta stop that motherfucker. I'm racing this twin engine, I'm blowing my mind so fuckin' much, man, going through the quarter, man, was beautiful. You know, you just scream through there, all this groovy feel-

ing there. But as soon as you fuckin' cross that quarter, man, you can see it comin' and that's when you gotta shut off real quick 'cause they don't build dragsters, with that much, that's why you got parachutes and everything. Them fuckin' guys are panicking to stop that motherfucker— he got it goin' and now he got something he can't handle. You know, I been in that spot about five times, man. Like there was a swamp, see, at the end of the drag strip in Florida, man, it was all water and muck and bullshit, well, that'll stop you. And, like, they picked me out of it, three or four times. They just don't give you enough room to stop. It would just be beautiful, man, just to screw on and screw it on as tight as you could, man, and not have that fear of having to stop, see. Where you could just ride for maybe a mile, man, and you'd just come to a coasting stop.

ZIPCO Hey, you take it on the salt flats too?

CAL No, I never have. See. You know what, I got pitchers. Moving pitchers of me draggin' that thing. And you can see, you can see the wheel come off the ground about eighteen inches when I shift. You know. When I shift, see. I had a four-speed transmission, like I ground low and second out. So all I was using was third and fourth. When I shifted—when I shifted, you know, I was shifting around the eighth of a mile. And I was doin' about a hundred ten, a hundred twenty, right there, see?

ZIPCO Hey, put a different clutch in there maybe?

CAL No. You know what I ran? I ran with a 1934 clutch. The one—You probably don't remember this one.

ZIPCO No. I sure don't.

CAL Because they—they're different, they adjust different and everything.

The adjustment was perfect on it, hey, 'cause it had a bolt in the middle that you adjusted. Instead of those always four bolts around.

ZIPCO Oh yeah?

CAL See, it had one. So when you adjusted it, man, it was even pressure all the way around. The old clutches are better than the new ones. They're real weird and they were stronger, see?

ZIPCO Yeah, you can put a big washer there. Bolt it down in there.

CAL That's the way a lot of people do it. That's a good way, too, hey, so that washer's even all the way around. Right?

ZIPCO Yeah.

CAL And then you got it made.

ZIPCO What the hell's it doin' down there for, layin' around doin' nothing. Hey, you should make money with that fucker.

CAL I don't want to race no more.

ZIPCO Why not?

CAL I'd rather sit down and get loaded.

ZIPCO Scared, huh? That's an easy way to make money, ain't it?

CAL Yeah.

ZIPCO Well, what the fuck?

CAL The whole thing of it is you gotta put in, you know, you gotta put in a lot of hours in it. You don't just ride that son of a bitch. You put thousands and thousands of hours in that son of a bitchin' bike. You're out in the fuckin' garage. You know what I used to do, man? I used to go out in the garage, man, toke it, you know? And I used to get loaded, man, and I used to trip on how to make a part, man. How to make it better so I could go faster, you hip to it? And that takes time. You don't just do it out of your head.

ZIPCO Oh, them four carburetors, two on each cylinder, you put them on your

bike or not?

CAL Yeah. You know what they were, they weren't Harley-Davidson ones.

ZIPCO What?

CAL They're Jaguar carburetors. Did you ever see a big Italian carburetor? You know, about that big, man? Sittin' on bikes. Well, they were just like that, but better.

ZIPCO What then? Delortos?

CAL Yeah. The Delortos, right. You seen Delorto carburetors? They look something like that when that gas shoots to 'em. And I had the funnels, funnels on each carburetor, and they were pointing forward, see. So it would be almost like a blower. The air was blowing in there instead of sucking in there, see. It was pushing it through. And I was running fuel, not gas.

ZIPCO You had it bored out bigger or what?

CAL A hundred cubic when I got through with it. I had four carbs and I had a hundred cubic inches per engine, two-inch valves, all ported and relieved, see. And I had the biggest cams I could put in there, man. The hairiest cams.

ZIPCO How the fuck you start it?

CAL My mechanic started it. He weighed 237 pounds, he started it. One kick and that fucker started.

ZIPCO Fuck.

CAL Because both engines were timed together. So if one engine didn't fire, the other one did and it overloaded and started the other one. You hip to it? And they both ran beautiful, man. And I had both, both engines tied, see, so that I'd have—I'd have equal amount of pressure going through the transmission from each engine. You hip to it? In other words, it wasn't overloading one engine.

ZIPCO Was one engine hooked up to the rear end?

CAL Yeah yeah. I had them tied together, see, with the primaries, you know. They were tied together so they were firing each time. Perfect.

ZIPCO Who the fuck? You do that?

CAL Yeah and then—

ZIPCO You know how to time stuff pretty good, huh?

CAL Well, all right. Good enough, you know, for me. Right? It's good enough for me. I can time it that good.

STATEMENT

JOHNNY GOODPASTER Age Forty-two. Motorcycle racer and BSA dealer

An old man walked between two parked cars in the middle of the block and a cycle ran over him and killed him. It was all in a short space it happened. The next day in the paper the headline said, "Cyclist Kills Pedestrian," and then it went on a two-column, full length of the page talking about how he had been involved when he was a kid with a juvenile delinquent—he had stole some beans somewhere and

he was shot in an attempted robbery. He wasn't in the robbery, he was in the store, and while he was running to get away he got shot in the heel. And it told about that. It also told that at one time when he got out of the army he brought a submachine gun home with him and was fined by the government for not paying income tax on this. They also put that in there and they wrote up the story so detrimental and so one-sided, this guy couldn't possibly be prosecuted under any act that he committed as far as that particular accident went, simply by the biasness of the paper. The same thing happened the next night, a car driver ran across the center line and killed four people in the car and he had been under the influence of alcohol. That was the extent of the whole write-up of the accident, five lines. This guy had been guilty, more guilty than this other guy. The other guy had been jaywalking that got killed. But these innocent people driving down the street got killed by a drunk. Four lines is all it warranted because this guy conformed to society. He drove a car and he drank.

I started out in a garage with hardly anything at all. And started tooling machines, my own. My father always said riding on the street was dangerous, so I started riding in the woods. Then scrambles, then I got a professional license. Commenced to get myself smashed up about the first race. And then they wouldn't give me no license for five years because my leg was so badly screwed up. And then they finally gave me a limited license for road racing, but then I garnered enough points to be an expert, so they give me an all-out license again. See, the doctor has to okay you to race and it's what they say.

Right off the bat as a professional racer a fella ran into me and broke my leg in seventeen places. And that kinda put an end to it. I was laid up for a year with a bad leg. And when you stop racing, riding, you forget. You forget how to ride, in fact. Most people said, well, now that you got hurt you have to quit. But I didn't quit. I told the other riders, well, it's an occupational disease. You get scratched up a little bit. It happens. You didn't want to do it. Most people say, well, it's a psychological block, you want to go out and get maimed and killed. That's why you race motorcycles. I don't see it that way at all. If you want to race motorcycles, that doesn't have anything to do with getting hurt. People go out and take more chance going hunting in the woods with their drunken friends and gettin' shot than anytime you race a motorcycle. I'm sure. In fact, I would venture to say, without no evidence at all, more hunters get killed accidentally than your motorcycle riders. And I don't even have to look at a safety pamphlet. I'd almost bet it. I talked to a friend of mine once and he said they went hunting and they drank for days and days and days and finally they come to this big thicket, they saw some bears going there and they said, we'll surround the thicket and we'll fire into it and they did and it's amazing no one got killed. They were all trapping each other in their own crossfire. He said we didn't realize it until after we got home and somebody brought it up and said, hey, we coulda got hurt. A golfer can get beaned with a golf ball. Of course things that the Great Society condones, that's all right to do. But they just never happen to get around to motorcycles, so, you know, that's no good.

A lot of people seem to think bikes, particularly motorcycles, lead to some kind of motivation, that's why guys ride 'em. They think it leads to something obscene. I don't know why, but obscenity

and motorcycles travel hand in hand. That's why Honda's done such a great job in leading people away from these beliefs. But many people don't let their daughters ride on big Seventy-fours because it looks obscene. They really have, I've heard people say this. But most people, they don't say anything when an airplane flyer or a man takes up an airplane hobby and decides to go out and crash his little Piper Cub in the field. They don't say anything about it. But if you happen to miss the light and slide across State Street on your bike, you're a criminal. And there's some pretty shoddy pilots in the world, too. Same way with cars. People can go down the road reckless, destroying, rampant, drinking, they might get stopped by a cop, might get a ticket. Maybe, maybe not, all depends on the officer in charge, if he drinks too he don't consider drinking a fault. But if you're on a motorcycle and you weave in and out of traffic a little bit, even though it is safe, you're a menace to the highway. 'Cause anybody in their right mind knows what a 300-pound motorcycle can do to a 7000-pound Cadillac.

STATEMENT

RODNEY PINK Motorcycle racer

Everyone wants to be part of something. You want to carry a flag or wear an emblem or do something. I've seen this in my own club. People wanted to join my club because it has a reputation, a good reputation. But they don't want responsibility or work. They just want to be part of something. And, you know, be able to forget it or just take it or leave it. And generally people that join most of the outlaw style of club are that sort of person. They want to be part of something and yet they don't have the initiative. They don't want to do anything, they don't want to have any responsibility unloaded on 'em. Like an outlaw club will almost, almost I say, never promote anything. Maybe a dance is the biggest thing they'll do. You know, if they happen to dig it.

Because as soon as you promote something, people get burdened with jobs. They have to take away from their baseball games and something like that. The average person that goes in for that sort of club is very low on initiative and high on talk. In my club you're constantly hung with a job. But you don't wear the colors unless you're working for it. And when you wear the colors you really feel like you're doin' something. I wouldn't race a motorcycle if I didn't have green on. That may sound funny, but I went out and spent eighty dollars for a pair of leathers. And I had 'em custom made in green, green leather. It's almost impossible to find. 'Cause these are my club colors. I'm proud of my club. We'll go to a racetrack whenever it's needed. We'll spend the

61

whole Sunday there. In the hot sun with the bugs biting on us, swinging shovels and pickaxes. Cutting a racetrack out of the woods. So that other people can ride, people that want to ride but don't want to bother with the work.

My club's a riders' club. It's a club with approximately thirty members who believe wholeheartedly in sponsoring events for the riders, the motorcyclists, to better the sport, and no noisy pipes are allowed in the club, no ape hangers. It's not an old man's club, there's a lot of kids in it. Guys my age that just like motorcycle riding. We're not out to look special or feel special. Being on a motorcycle don't make you special at all. And a lot of guys figure that it does. It's like that clown pulling out of the toll booth sittin' in the middle of a lane. He was on a motorcycle, so he felt special. He can sit there. It's a big world, man. If you don't get shoulder to shoulder an' learn to roll with the waves you're gonna get either walked on or awful frustrated. You want to see just what it's like just step out into a nice big old fat ocean all by yourself in a little rowboat and see just how microscopic you are.

MEETING THE ANGELS

CAL

I was in the Straight Satans. I had the Straight Satan colors. That's why I did this, man. See, because they thought that just because they were fuckin' Angels they could fuck with me, you hip to it? And, you know, I'm sort of like a junior Hell's Angel. My club means just as much to me as his club does you know? Because I was in this club for a long time, too, the Straight Satans. Not the Satan's Slaves, the Straight Satans, different club. That's why I fucked over those two guys, Angels. I got this new scooter, see? I just got this new Triumph, you know, and I already broke it in and everything. I just got through gunkin' it down and everything, polishing it up. 'Cause it's brand, spankin' new. Breakin' it in. And so, after I get through polishing it, I decided to take a little putt with my scooter. And I'm trippin' along on the freeway, you know, mindin' my own business, drivin' slow like I usually drive, sixty-five, just puttin' along, staying up with the traffic. 'Cause in town on the freeways, in town in Los Angeles, man, they go sixty-five, not forty-five, thirty-five. You know this freeway, the Dan Ryan? You hip to it? You know the mileage you have to go? Forty-five miles an hour. They hold that as a minimum, that's your minimum speed, forty-five on the freeways in California. But anyhow, I'm trippin' along, way out, man, I'm out about Pomona, and these two dudes come up to me in the back. And I'm puttin' along, just minding my own business. And one of them pushes my handlebar just like that, you know?

And, man, I'm in a panic. I'm going off the freeway into this ice plant. I don't know if you know what an ice plant is, but if you're ever in California, look alongside the freeway and stop if you want. It's just like watermelon, things. That's why it's called ice plant. And I'm going off at sixty-five miles an hour about. 'Cause he pushed my handlebars pretty good. I goes off into this ice plant and it's real slippery and everything, man. And like they cranked on and split, see? And so I'm hassling this ice plant, I'm really slipping all around, I'm going down is what it is, see? So I drops it down into second gear. By this time I'm just about stopped and almost falling, man. And I cranks it on. And I just, I sort of like— I'm flat-tracking out of that place now, you hip to it? I'm comin' up back on the freeway. I'm shootin' right straight up for the freeway. And I gets on the freeway, man, and I start chasing these dudes. And I really turn that goddam Triumph on, you hip to it? And then it was hardly broke in. And I come up to 'em and they didn't see me. They figured, you know, well, this dude, he's had it. So I'm coming up on 'em and they don't hear me, see? And I just come right up in between both of 'em and push both their handlebars, see? And then I cranked on, and I split for a while. And what I would do, man, is I knew, see, I didn't push their handlebars hard enough to do any damage to them—to knock 'em one way or another. Just more or less disturbed their driving. 'Cause you don't have that much leverage when you're using both hands, alongside. And so, anyhow, I'd wait for 'em. I had a brand new Bonneville, see? This is about '59. You know who built it? A guy named Kulan. He's in Jacksonville, Florida. And that fucker could really go, you hip to it? I had all the best

cams in it and everything from Kulan. We put cams in it. And Kulan pistons and whatnot. And I'd just wait for these guys, you know? To pull up on my tail, man, about ten feet away, and then I'd turn it on and I'd split. And then I'd wait for 'em. I was playing with these people, man. I played with 'em for fifteen miles. And this was blowin' their minds, see? So I said, well, I'm tired of this little game, 'cause I didn't want them two to catch me. So I turned it on. I really turned it on and I just split out of sight. I sees this cafe comin' up, so I pull over to the cafe, you know, and I decide to get me a cup of coffee. I put my bike on the center stand and all that jazz, went inside, ordered me a cup of coffee. And by the time like the waitress got to me and served me with my coffee, I heard these two bikes comin' in like. They caught me. You hip to it? So they park their bikes, put 'em on the kick stand and as they're walkin'— they parked their bikes behind my bike, in other words, I couldn't get out, see? And as they're walkin' by my bike one of them starts to sit on it. And so I come out of my tree. I figure, what these dudes gonna do? Fuck up my new bike? Like kick in the carburetors? And spokes and whatnot? Gonna play some games? So I come out the door and I says, I hope you guys don't get no ideas about that bike. You know, like I'd get salty. In other words, I told 'em how it is. And so this guy, man, they called him Jesus 'cause he looked just like Jesus Christ. The fucker had long hair, way down here, man. And it was combed straight and beautiful hair, man, you know, for a dude. Anyhow, he acted like God, too. That's another thing. Every time we'd go on a run he'd find the highest place and he'd pray. You hip to it? The dude was a hypnotist, too, man. He used mass

hypnosis. A whole group. Are you hip to this now? The dude was an artist and here he was a Hell's Angel. And he spent some time in prison, man, with a hypnotist, that's how come, see, the hypnotist was in there for doin' some illegal scene. But anyhow, he was the one sittin' on my bike. And the other guy, man, was just—he wasn't too big. This guy, this Jesus, man he was about six four, see, and about 230 pounds, big mother. That's why he acted like God. He was big and bad. And this other guy was just, you know, a dude like Funny Sonny. And so they ain't said a word to me. They're bummering my mind now, see, they ain't talking one way or another. They ain't even talking to each other. While we were outside, there was a span of maybe about three of four minutes. And three or four minutes is a long time when you don't know if you're gonna get hassled or not. And so the guy got off the bike and he says, let's go have a cup of coffee. You know? In other words, he hung it up. They decided not to hassle me, right there. So anyhow, we're having a cup of coffee and we're talking about each other's clubs. And it happened to be that I was straight, too, you know? In other words, I turned them on to some dope and they turned me on. Like we had a mutual scene right there, you hip to it? And so we went outside, we did up a couple of numbers. This is before we split from the restaurant. And we started talking about each other's clubs. And they invited me over to their meeting. 'Cause this is where they were going. See, when they started hassling. They were going to their meeting, I hassled their mind so bad they hung up their meeting, man, to catch me and fuck me up. 'Cause you don't fuck with Angels unless you want to be fucked with. See, in California. Anyhow, so they invited me to their meeting. Then after we got through smoking the joints, we split off to the meeting and we played tag going there. You ever play tag on a bike?

PICNIC

FUNNY SONNY Age Twenty-eight. Ex-Hell's Angel. Member, Chicago Outlaws

So I went to the Stoplight one night. Now this is my first time at the Stoplight and I met Joey. And Andy, and I met Wahoo, oh there was a couple others—I can't think of their names right now. But we partied, I introduced myself, you know, and everything. Fine, the Outlaws. I had heard of 'em and now I met 'em. But they really didn't turn me on. Because they really didn't at this time show anything. So Donna, Donna, my wife, she was irritated at me because now I was ridin' my bike again. I was startin' to hang around with another outlaw element, and she didn't like it. So we started arguing and fighting about this. And eventually,

which was about a month later, around the first of June of last year, she left and went back to California. So my house that I had out in Wheaton, I just turned it into a party house. I had murals on the wall, I had the Outlaws' emblem on the wall, the Angels' emblem on the wall, my Disciples' emblem painted on the wall. I had a big living room, I had nothing but parties. So James the Third, that I met first, had introduced me to the Outlaws group, came out to the house, partied— we were sort of, I let him move in with me, you know. And I heard about this picnic, they were gonna have a picnic here last year. I was invited to go as a guest. So I went down there on my bike and I rode in there—this was out at Starved Rock, they had their picnic out at Starved Rock. And we went out there and it was groovy, it really was. I tell you, it was a kids' picnic, it started out to be a kids' picnic, you see, and I didn't know it was strictly a kids' picnic. They just said it was an Outlaw picnic. I figured drinkin', which it was. They had fifteen, twenty cases of beer there and some wine, everybody was drunk anyway. So I rode my bike down to the picnic. Now everybody's there at the picnic, now you gotta check this thing out now. I'll try to explain it to you best I can. There's a little dirt trail, I mean it's hard gettin' down, just ridin' a bike by yourself, you know, even if you're a good dirt rider. And I was smashed out of my mind. So I set James the Third on my handlebars, he's got a jug of wine. This other guy, one of the Outlaws, was ridin' behind me, he's got a jug of wine. And I'm ridin' my bike and I got a jug of wine. And we're jammin' down this little dirt trail, doin' about fifty miles an hour, see. And as you whip around out of the trees, out of this little dirt trail into a flat plateau, there's a big

flat plateau and over to the far right of this plateau is trees and picnic tables, a couple of picnic tables where they have the picnic. But straight ahead is a little hill-climbing thing. It's down into a gulley and you can hill-climb up out of it, see. So I rode right straight across this straight plateau, drinking wine, three guys on my bike and everything, right up to the picnic area. So I met everybody, I met Big Jim, Ray and Aggie and I met all the Outlaws. Well, see, they were a little skeptical of me at first, you know, because they figures this scronchy guy, what's the story? And Bruce and Gail, you know Bruce and Gail? Gail says, well, what do the Angels look like in California? And Bruce turned around and told her, he pointed at me, he says, figure about 150, 200 of him and you got that point made out right away. And I was lookin' bad—I was at my best, at my best. I was greasy, grimy, I hadn't taken a bath in about a week, you know, smellin' good and everything. And people didn't really understand me, see? So I had some money in my pocket, so I went up and offered Johnny five dollars. 'Cause I was a guest there, but I gave Johnny five bucks for any kind of food I would be eatin' there or any booze I'd be drinking. Because I was not really an Outlaw. All right, so I ate. So they offered me a fork to eat with. Well, I was drunk and I was gonna show a little class, so I didn't eat with a fork. I ate with my hands and scooped it up and shoved it in, it was dripping off my chin and down my chest and I was rubbin' it in and everything, drinking wine. So then they wanted to hill-climb a little bit. Everybody wanted to hill-climb. The guys with the choppers, and Charlie, Crazy Charlie with his three-wheeler, he was even trying to hill-climb. How the California people hill-climb with a chopper. So I gets down to the bottom of

the hill and everybody's on top of the hill, see, taking pictures of this and everything. So the first time up over the hill I didn't leave the ground. I just come up and bounce over the top. I was a little leery of it, I never done this before. So I really get brave, you know, that wasn't bad at all, see. So I turn around, I go back down the hill, down the other side, to make another run at it. This time I go just a little bit faster. So I come over the top and my front wheel comes way off the ground and wow, what a thrill that was. This is really groovy. So I go make a big circle and before I start down the hill again, they run up to me, yeah, show us, show us. Somebody hands me a big jug of wine, I take about thirty swallows out of it. I'm really gonna give her hell this time. So I get all the way down to the bottom of the hill and I'm comin' up the hill, you know, the rumble of the engine and everything, and I'm turnin' it on a little bit more and just about maybe twenty feet from the top they say, screw it on, Sonny, screw it on. So I really got on it, see, come flying up over the top, both wheels leave the ground, I'm in midair and I'm panicked. Here I am, hanging on these high bars, I'm goin' crazy. My front wheels going like this and I hit the ground. Well, the bike falls over, see. It falls, hits the ground, crash. But it's still runnin'. So now I'm gonna show unlimited class. I'm gonna keep the bike running, pick it up, it's still in low gear, run along, and I jump back on the bike, it's still runnin' fine. Turn around, I got my leg messed up, you know. I'm bleeding a little. To the left, to the right. So I figure, you know, I've really accomplished something. So here comes this little guy on this Honda. This guy ain't gonna show me up, you know, figurin' maybe this little guy on his Honda can do it better than

I can. So he goes over there and he takes about four good swallows of wine. And he gets sick right away, instant sickness. And he pukes it all out. But he makes it, he wipes his mouth off, shows a little class, wipes it on his pants. Little Honda guy, you know, helmet and everything. So down the hill he goes. So he's comin' up the hill and he's goin' good, he's lookin' good, he's comin' up like crazy. I'll bet he's doin' about thirty-five, forty miles an hour comin' up that hill. He gets right to the top, he soars through the air and he comes down. He hits the ground, *vroom*, and he falls over. So he's gonna pull my shot, you know, he's gonna keep his bike runnin', he jumps on it, but he doesn't realize something. His bike is headed in the wrong direction, he's headed for a cliff. And he jumps on and gives the gas and over the cliff he goes, messed his whole bike up and he's gone. He never came back again. That was too much. So then I figured, well, I'm gonna show 'em one more time. And when I came up, there was this, you know these little caterpillars that fly through the air? They soar through the air from tree to tree on webs, on a little web. One musta got caught in my hair, a long green one. Musta been the size of a good pencil. So here's Aggie, all the girls fixin' food, they're all eatin' and I walk over there with this caterpillar. And I put it on my tongue. Now if you ever tried to swallow a caterpillar, what you gotta do, there's a thing to swallowing a caterpillar. You know how they're barred, like how you say it? They're barred a little bit, like you can't go against the grain on 'em or something. That's how they use themselves to crawl along the ground. Well, you face him out. Face him out on your tongue. So he's crawling forward. And then you gotta put him way back on your tongue. And then try to

swallow him. He gets down here, he starts crawling back up. 'Cause by now he's hanging on, he knows he's on his way down. He's gonna hang on for dear life. And Aggie seen all this. Now I swallow, the caterpillar is gone out of sight. Open my mouth, show everyone it's gone. Then I know he's crawling, I can feel him crawling back up my throat, see. So I got my mouth closed, and you know, it's closed and everybody's eating. And I'm at the table and everybody's eating, we're talking and I open my mouth just a little tiny bit and this little fuckin' caterpillar comes crawling out of my mouth. About four people got sick, see. So then I yelled to everybody, I said, ah, you ain't gonna get away from me, caterpillar. So I crunched my teeth down on him and I chewed him up real good. So I crunched my teeth down on him and I swallowed. So I had a lot of food to eat that day. Because everybody got up and quit eatin' their food. Oh, Christ. That was good. That's when I really met the Outlaws, really met 'em good.

BENNY

KATHY Age Twenty-six. Wife of Benny, member of Chicago Outlaws

Police Nab Motorcycle Driver After Wild Chase

It took six police squad cars from Elmwood Park, Norridge, Harwood Heights and Chicago to slow down a motorcycle driver Thursday who hit speeds of 85 miles an hour in his wild ride through suburban and Chicago streets.

Brent Bauer, 19, of 7446 Addison, Elmwood Park, was arrested and charged with eight traffic violations by Elmwood Park Police Sgt. Anthony Fanella and Patrolman James Caliendo, but not before he reportedly:

Ran through two stop lights, hit speeds of 85 miles an hour in two 20-mile-an-hour school zones and abandoned his motorcycle.

As they pursued him, he increased speed and eluded them in a dizzy chase which ended at 5510 Montrose, where he abandoned the cycle.

During the chase, Elmwood Park police radioed the situation, which was picked up by police in other suburbs and Chicago.

As six squad cars closed in on the cyclist, he fled to a telephone booth at Central and Montrose, where he was arrested.

Police said Bauer is married, father of two children, and is a member of the Chicago Outlaws motorcycle club. He was convicted of drunken driving May 17 and his license was revoked.

Bauer is free on $2,500 bond and will stand trial in Park Ridge traffic court on June 17.

Last year my girlfriend called me up and she asked me to come down to Grand and Division. She needed some money. And she said it was a bar. She says that the guys were havin' a meeting there. Well, I didn't know the guys or anything, so I went there and I never felt so out of place in all my life. I walked in there and



I had white Levis on, I had a sweater on. And I looked and the first guy I seen was Corky, with an earring hanging out of his ear, his belly button showing, like half-naked. To me it was like half-naked, you know? And here he's hootin' and hollerin' and he scared the livin' shit out of me. So I sees my girlfriend and I goes over to her and I sits down there and I'm takin' everything in. And all these guys kept comin' up to me sayin', you know, different stuff like you need a man, or you want to come live with me? And I was about ready to just run. So I says to my girlfriend, well, I gotta go. And she says, oh, they're not that bad. Just sit here. So then she introduced me to Pete and Pete asked me if I wanted to go out and I took one look at him and I says no and I was so scared I couldn't even talk, and I says, no thank you. I says, I have a date at twelve o'clock, I have to get home. So then they starts, Cinderella's got a date, she's got to be home at twelve o'clock. And they're scarin' me 'cause they're sayin', we ain't gonna let her go, and the more they said that, they kept gettin' into a huddle. And I knew they were talkin' about me and I says to my girlfriend, see, they're plannin' something. I says, I'm gonna go. So I was gettin' ready to get up and all of a sudden I seen Benny and he was standin' at the end of the bar. And I says to my girlfriend, boy, who's that good lookin' blond guy? I says, he don't look like the rest of these guys. She says, oh, Kathy, you don't want go out with him. She says, because nobody wants to go out with him. And I says why? And she says, because he cracks up on his bike. Every time he gets up on his bike, he has an accident. I says, oh, okay. So she ordered me a Coke and I sat there and was shootin' the breeze with her, and all of a sudden Benny came up behind me

and he started talkin' to me. And I says, well, I gotta go home. So I walks out the front door real nice, bein' grabbed about five times so that when I got outside, I could see on my slacks were just hand prints all over me. So I'm standin' on the bus corner almost in tears, thinkin', oh my God, something's gonna happen to me yet. And they all come chargin' out of the front door. They had Benny start up the bike and they grabbed me and they took my purse and they put me on Benny's bike and they told him to take off, they'd meet him on the expressway. He takes off, he goes through the stoplights and everything, so that I wouldn't jump off. And I wouldn't have jumped off anyway 'cause I was scared shitless, I never was on a motorcycle in all my life. So finally we gets out on the expressway and all the guys come and they're laughin' and laughin'. So we went to the Green Duck out on River Road. But before we got there I'm sittin' on the bike real nice. I figure, you know, at least he'll get me home. They're not doin' nothin' to me. All of a sudden he takes his hand, he puts it on my back like this. I said, whatta you doin'? He says, I'm just checkin' so you don't fall off. I says, okay, like an idiot, you know? I thought he was really checkin' it out. So the second time it happened I says, don't worry about me, I says, I won't fall off. He says, okay, and he was real nice about it. Until we gets to this Green Duck. By that time I wasn't scared no more, 'cause Johnny was real nice to me. He says, don't worry. He says, I'm president of this club and I wouldn't want nothin' to happen to you. He says, they're only havin' fun and this one guy wanted to go out with ya. So I says, okay. I goes in the washroom and all the girls follow me in there and they start givin' me this bull-shit where now that guy's mine and that

guy's mine and that guy's mine and that guy's mine and you better leave him alone and all this other bullshit. I says, yeah, I knew who this one was and that one was. So I goes back out there and I paid for my own drinks and everything. That's how chivalrous those guys are. But at least I wasn't obligated to 'em. But that meant I didn't get home till four in the morning. And I swore I'd never go out with them guys again. Never. Because they're just like animals. You know, they didn't talk the same way I did, it was everything f this and f that. By the time the night was over my ears were ringin' from listenin' to 'em all braggin'. So Benny came home with me, brought me home and my boy-friend was sittin' on the front porch. So I says good night, you know, adios, and I said to this guy I was goin' with, I never want to them guys again. They're really idiots. So the next day Benny calls up and asks me if I want to go to a race. He called me up on Sunday, I says, no. He called me up all during the week, I says, no, I'm not goin' with ya. I says, I can't get a baby sitter. So finally one night he planted him-self here all night and wouldn't go home. So then my boyfriend would still come over and Benny would still sit here and I'd tell him, you better go home. And he wouldn't go. So finally my boyfriend left and Benny was still around. So he says, let me take you to the meeting. Every-thing'll be real nice. So I went to the meet-ing. After that, I started goin' out with him. I only went out with him, never with any of the other guys in the club. And five weeks later I married him. I ain't really sorry, the only thing is I thought I could change him, you know? Every woman thinks that she can change a guy. Not to her own ways, but to be different. Not to be different, but to be, I don't know. Like he's wild. I used to think he'd

get over that. But he don't. And he's got a vicious temper. He's got a temper that all you have to do is say two words and he'll knock you on your rear end. And I ain't used to that. And I ain't gettin' used to that, 'cause like I told him, I don't look good in black and blue. And I know the bleeding stops, but still, one of these days. I ain't got that much blood left. I think seriously, a lot of times I think like I went to my lawyer, I had papers drawn up for a divorce and everything else. But then I can't go through with it. I don't know why. 'Cause I did it once, you know, why can't I do it again? And the first time I had more to lose than I have now. Now I really don't have nothin' to lose except to lose him. And you think, really, like Sonny says to me—you know, we were comin' back from Columbus. He says, Kathy, I'm gonna tell you somethin'. Once you go with a guy from the Outlaws, he says, you'll never go back to any other guy. And I think it's true. 'Cause after a while you get just like them and you start thinkin' like them and actin' like them.

Comin' home I'm always afraid some-thing's gonna happen. You're gonna see one of 'em layin' there and I always think about Benny goin' down with the bike. Now the guys know that he has no driver's license, but they're gonna give him a bike to ride tomorrow. Now this is idiotic. They know he gets stiff. They know that when he gets stiff and he's on a bike he can't control himself. And that's one of the reasons I don't want to go, 'cause I'm afraid to go. I'd like to go, I enjoyed my-self last year, but I'm actually afraid to go. If Benny hits me, there's about eight or nine guys in the club, they'll back me up. They won't let him hit me. And this includes Johnny. 'Cause Johnny told the guys at the coach house one night. I was mindin' my own business and Benny got

stiff and he started chokin' me. For no reason at all, he just started chokin' me. 'Cause he thought I was lookin' at somebody else. I was lookin' up at the balcony 'cause everybody was standin' on the balcony, so I'm lookin' up and everybody's wavin', you know, and all I did was go like this and he comes and starts chokin' me. And Eddie comes jumpin' off the balcony, gets onto Benny and says to Benny, don't ever let me see you do that again. Here I didn't even know it, but before Johnny left he told the guys, don't let Benny mess her up unless she provokes him, he said. And I didn't provoke him. I didn't do nothin'. And he says he ain't jealous of me. I'm jealous of him. I am. I'd kill anybody, no, I shouldn't say kill 'cause I ain't got the heart to kill anybody. But still I get mad, you know? I don't like to see girls messin' around with him, but yet he turns around and he's messin' around with the girls. You can't win. Either he'll get in a good mood when he's drinkin' or he'll get in a bad mood. And Benny's a fighter. You've seen Benny enough times that no matter where he goes he'll get in trouble. He'll start a fight. Sometimes I wish he'd pass out at eight o'clock at night.

As I said, I know a lot of people here in Lakewood. The guys here, I grew up with or they grew up with me. You know, like when I was really bad off, I didn't have no money or nothin', like the night I went to the hospital to have the baby one of the guys came over here and took care of the two kids for me, fed 'em and changed 'em and everything else while I was in the hospital, until my ma came and got 'em three days later. The guys, they'll do a lot for me, but at same time they want to see Benny and I break up. Because when Benny first came around, there was a lot of trouble because all the guys that I knew, they always said, well, why don't you go out with us, you're goin' out with something like him, and all this bullshit, and then Benny got into that knife fight over here with the guy that I used to go with years ago. And things didn't go so good after that. Now everybody's afraid of the old man. They're all afraid of him. Even the big guys. Well, it was the big guys he got in trouble with. Then the Outlaws came down and they were gonna burn the place out. It was bad. The Outlaws—Corky, Johnny, Wahoo, Bruce, a whole bunch of 'em. They were gonna burn the tavern across the street 'cause that's where it happened. And Benny wasn't even in the tavern. He was outside the tavern. Benny was outside the tavern talking to Larry, you know, Larry, the tall guy with the beard that drives the bike with the frog on it. He's a good friend of mine and I introduced him to Benny and he called Benny over there to look at his bike. He just got a new bike and there was about five or six bikes there, so Benny went walking over there. And a fight started inside the tavern. So the guys that started inside pushed their way outside and they looked at Benny and they said, there he is, there's another one. So they started fightin' with their fists. And these guys, one's name is Nick Pileggi and one's name is Tony Pileggi and I don't know who the other one is, and they all weigh about 250 pounds. And they're the bullies in the neighborhood. Like they beat up anybody and everybody, old men and old women, they don't care. And everybody in the neighborhood's been afraid of 'em. And I had told Benny a long time ago, I said, don't mess with them. Because, I says, they'll kill ya. Well, he started fightin' with 'em and all of a sudden the one guy hit him and Benny flew right to the white line in the middle

of the street. From the corner to the middle of street. He got back up and he started and all of a sudden the other two came up and there was three to one. So Benny started runnin' home here and the guy was carryin' a shovel. So Benny came in the house and he grabbed a knife. Benny went out there and they weren't out there, but they were knockin' all the bikes over. So Benny went across the street with the butcher knife and told 'em, cut it out. And they didn't cut it out. And the one guy started comin' toward Benny, so he took the knife and cut him from here to here. Took out two of his teeth and part of his ear. So then Benny comes in the house, he says, call the police. He said, I just killed somebody. So I wanted to call the police, but all of a sudden the door was busted in and there was these two big guys. And they had the cement shovel. And they cut around his arms, he had his arms over his face. They cut him here and here and took half his ankle off. They put him in the hospital. They tried to get him into a private hospital and they wouldn't do it. 'Cause he was under police guard and stuff. And here, if I woulda known it, them assholes, they paid the cops fifty dollars not to press charges against 'em for breaking in and entering. Sayin' it was all Benny's fault. So Benny got out of it. Them guys came and crawled to Benny, beggin' him not to sign a complaint. Even the guy whose face was ripped open said to Benny, please don't. 'Cause these guys are twenty-eight, thirty years old, what they pickin' on a nineteen-year-old kid for? He wasn't even in the tavern. For breaking and entering, you know, it all pointed to them for bein' their fault. 'Cause Benny defended himself from them breaking into the house. And it was their word against ours. He was bad. I had him in a hotel for three weeks,

he couldn't even walk, in order to get him to a doctor, because we didn't have no car at the time. And I was afraid to come back here because a lot of 'em were threatening that I was gonna look the same way as them. That's when Johnny got mad because Johnny was in Pat and Tom's, him and Wahoo, and they started talkin' to different guys and they said, I wonder what that guy's gonna do now, you know, now that his face is cut up. And somebody says to him, well, I'll tell ya, the guy's wife is gonna look the same way as Tony Pileggi. And that's all they had to say because Johnny got the guys and they busted up Pat and Tom's. I've had nothin' but trouble since I married Benny. I've seen more jails, been to more courts and met more lawyers and it's only a year. That's a short time for so much to happen.

Park Ridge. He comes from a real nice place. Good neighborhood. Park Ridge is one of the richest. Benny's father died. Benny's father was a big shot for the telephone company. But you know what? Benny has no feelings. From what I hear, even when his father died he showed no feelings. He said, he's better off dead. Benny thinks that when you die you're better off then when you're living. You know, like when his dad died he said, it's just as well, he's better off that way. When his friends got killed, well, they're better off that way. No feelings. My dad always told me it takes a lot to make a man cry, an awful lot. You know, they don't get hit in the head and start cryin'. Not a real man. I seen my father cry twice in all my life. And once was when his father died and then when my mother almost died. My mother was in the hospital. And I mean really cry. And I always believed him and when I was gettin' a divorce from my ex-husband I never seen him cry until it was time for us to get a divorce. And he

was thinkin' of the kids and all this bull-shit. Whereas Benny, I seen him get worked over with blackjacks. I seen him gettin' stitched up with no nothin', you know. Just stitchin' him up when he was wide awake and everything else and you don't see that guy shed a tear. But twice, no three times I seen him cry. The last time I seen him cry was when he was sittin' in the jail over here and he says to me, I says, Benny I don't have twenty-five hundred dollars to get you out. So he says, there's only one thing, and I got him out anyhow. I borrowed the money. Do me a favor, he says, when I get out I'm gonna leave here. But just don't ever, he says, just don't go with any of the guys in the neighborhood, he says, you deserve some-thing better. So like a stupid idiot I'm still stuck with him. I coulda got out a half-dozen times while the goin' was good. 'Cause every time he's gotten in trouble the first thing he'll say to me is, well, I'm gonna leave. And I think he just says this so I'll say to him, don't go, don't go. You know? And beg him not to. But you know, it's gettin' to be such a habit now that he's goin, he's goin', that one of these days he is just gonna go. He says he'll never leave, but then he'll get on wine. Then he says, oh, it's for the better, he's gonna go, he's gonna go. But he don't go. You know what? If he'd just go, not tell me about it, but just pick up and go, then it doesn't hurt so bad, you know? But when you gotta stay with him knowin' that he's gonna go.

Were you at the Stoplight when he got worked over that time? You shoulda seen him. His whole head was black and blue, his kidneys were kicked in. His back had scabs on it, he was bleedin' all over the place. He just stood there. You know what the guys in the club said? Well, one thing we gotta say about Benny, he's the only guy that stood on his feet from the club-room all the way out to the street without fallin' down. And there were guys hittin' him with stools and blackjacks and every-thing else. That's the only thing they say. When he got in trouble once before he put his fist through a window on Broad-way and Belmont and the guys, well, he got into a fight and he missed the guy and he went right through the window. His whole hand was wide open and he was still fightin'. And the first thing the guys said, well, Benny doesn't give up. He sees a little blood, he don't pass out. They like him because he's a fighter. And that's just what they need in that club. Because you know what? Half them guys in there are candy ass. There's a lot of guys in there that are candy ass. They'll just as soon turn around then to get in a fight. They don't care if they go to jail for dis-turbing the peace. But they ain't gonna go to jail for aggravated assault or nothin' like that. You know when them guys are big? Every single guy in the club I think is the same way. Benny stays in the club for security. A lot of them guys in the club, they stay for security, too. They figure as long as there's a bunch of them, they're all right. But get one or two sepa-rate and they ain't got a chance. They don't even bother gettin' in trouble. The first thing they'll do is take off their colors and I've seen this. I've seen the guys drop over here, they don't wear their colors. I've seen the guys. But they'll wear them when they're in a bunch. Why? 'Cause they're afraid when they're all by them-selves. 'Cause too many people are after 'em, for one thing. Too many people have a grudge against 'em. So if they catch 'em one by one, and that's what happened to Benny. Benny always wore his colors and when he did wear his colors and he was by himself, there was even trouble.

Even in the Stoplight. And he had a couple of his boyfriends with him, but from around here, you know. But he still got in trouble.

I went to my lawyer Monday. I come home here, there's ten guys on the porch. I went to my lawyer, they got papers against me, petitions against me. And you know what's the beauty part of it? Benny and I are in the back bedroom watching TV and all these jerks are out in front. 'Cause they ain't got no place to go, see? And I know 'em and so does Benny, but they don't have no place to go, so they'll come and they'll sit here. And it makes it look bad. The neighbors see it and this and that. So my lawyer says, keep 'em all away from there, you know, he says that it looks bad. So I had notes on the door, "no one is allowed on this front porch." 'Cause it's gettin' to be, the scene is sickening itself. Man, you go past the house and you see all these idiots and they are idiots, they're punks. Ah, they're trying to say that, you know, like the detectives were here, I was contributing to the delinquency of minors 'cause Benny's a minor, you know? So then they came here for us distrubin' the peace four times in one night. And I wasn't even home and neither was Benny. Then they have child neglect, abandonment and all that bullshit. When we were in Ohio? Well, I didn't abandon the kids. Dingy had the kids here. So they couldn't press nothin' on me there, but see, it's just the complaints that they get. Whether they're dismissed or not they're still there. And it don't look good. My ex in-laws live right across the street. And they're tryin' to get my son, the oldest one. So they're gonna do everything they can to drag me under to get the kid. But the only thing is they can't take one kid without takin' all three and I know my ex-husband can't afford to take all three kids. And he doesn't want all three anyway. They got him on income tax. Not evasion, no, you know what he did? The guy makes good money. You know, he went and filed, but he deducted each kid separately, plus the $2000 that he gave me, he deducted it all separately. Like $600 for each kid. And he don't give me no $1800 a year. It doesn't come out to, you know, the $600. So he got called in. So then Benny got mad at me 'cause my ex-husband came over here and he says, well, would you do me a favor? I says, what? He says, let me see your income tax to see whether or not you filed the kids, too. And I didn't. I just claimed Benny and myself. So I showed him the papers, so Benny got pissed off because I'm tryin' to help the guy out. But I figured there ain't nothin' wrong with him, you know? He's a good guy. I was married to him for seven years. I wish I woulda stayed married to him. I do. The guy had, I'm tellin' ya, he was so square, it was pathetic. But he was good, he was good-hearted. He'd come home, he never stayed out all night, he'd drink but not like Benny does. He never even seen the inside of a jail. He was square, but was good. He had money, too. And he worked, every day. Benny's been off a work three weeks. He said here today before he went to work he seen the mailman, he said, oh goodie, here comes our check. I says, whata ya mean, our check? He's waiting for the kids' check to come. And the mailman didn't bring it, so he stands out on Addison. He says, see that son of a bitch ain't even sendin' the kids any money. And he gets pissed and he's waitin' for the money so that he can go to Starved Rock, you know? So he has money for club tonight. And he's so goddam poor he didn't have a nickel in his pocket this morning. Well, he had thirty cents, that's

what he had. So I felt sorry for him, so I told him, I said, well, since you don't have to go to court till nine thirty, wait till nine o'clock, I'll write you out a check and you can take a cab. I hike from here to wherever I'm goin' and I put him in a cab from here to Franklin Park and back. Oh, I can't figure it out. It can't be love. It must just be stupidity.

CHOPPED SCOOTER

CAL

You see that old ancient piece of shit that I came on tonight? That fucker's Jim's, man. You ever ride Jim's bike, man? Try it sometime, it's an experience, I'll tell you. Everything's a fuckin' death trap on that cocksucker. No shit. Go down thirty-five miles an hour and you're going into a speed wobble. The fuckin' handlebars are cocked this fuckin' way. I think the fuckin' wheel's bent in the back. You can't get neutral in the motherfucker. It's a mind blower just to ride it. I like those fuckin' nice choppers. Go down on the thing and you got your fishtails right up here by your ear, you know, so you can listen to the tone. Man, you just go through the fuckin' gears and it's just groovy. You're on your own fuckin' scooter. You built this motherfucker.

You know what I dig, man? I dig them beautiful customized jobs. You know why? 'Cause I look at a scooter, man, that's completely chopped, man, and every part on it he either made himself or bought special for it. Now you look at that dude, man, and that dude's an outlaw. Whenever he rides, man, part of that scooter is him 'cause it's got his ideas and it's just him. Every scooter, see? Say you take a guy that buys a brand new Harley-Davidson, fully equipped. There'll always be a motherfucker comes along and says, well, I got one exactly like yours. 'Cause he can get it exactly like his. But all choppers are different. Every one of 'em, different. No matter how much alike you build, you know what I mean? They're all different. 'Cause everybody's melon's different. Everybody thinks different. So when I look at a chopper, man, I respect the dude because he made his. The dude over here, this dresser rider, man, he bought his. Never done a lick of work on it but maybe tighten bolts. That's the difference. And so therefore Jim can work on that motherfucker, see, because I don't like workin' on dressers, you know, fittin' all those bags and all that weird shit. Man, I love to work on engines and transmissions, man, and front ends, you know, customizing the complete front end. Like Shirley will see my brother's album. Well, it's my album too, and, my youngest brother's album too. I got one under him yet. He's married, too, you know, hassles around on an Ariel Square Four, completely chopped out of your mind. But he can't putt like me and Pierre

does, see? So he's not an active Angel. Yeah, I like these out-of-sight scooters, man. Do you know what my last scooter looked like? My last scooter, man, was a tin can, a '62 tin can. The frame alone, I spend two weeks customizing the frame. Had it raked out in the front, you know, the neck kinda set out a little further. And had it all molded to where it was you couldn't see one joint in it. And I took two Harley-Davidson gas tanks and chopped them completely in half and I put 'em together and I welded a seam inside so I could hold gas in it, you know. But the two caps were side by side and they were just like this. That was my gas tank, like a tear, man, and I had it molded in the frame, too. In other words, you could never take the gas tank off the bike. But it looked gassy. That was my frame. Everything was black lacquer, you hip to it? And then it had pearlescent underneath that. And the tank went into metal flake on the corners of the tank. Then it was black lacquer on top of that. So that it more or less wouldn't be grayish looking, you know, and the tank was flamed out from there. And then my fender, man, it came up and it had a weird scoop, came out like so and up like so. And in the middle there, that little diamond scene.

It looked just like a little flower. Like that almost. Well, like fingers of a flower is what it looked like from in back. And then there was plastic molded in between these fingers. Then this sat right on my fender, man. You know, on the end, and it was so beautiful. It was like you could see the light come in this way and it seemed to flow out. You hip to that? At night. And also, on the tanks it looked like wings of a bird. You hip to it? With the little silver feathers right at the elbow. It looked like, well, like an eagle charging 'cause it had little red type seams. And then from there I had a sissy bar going up. Up, and it curved up on the top, and in the middle of it, man, I had this sword that went jagged. Straight sword about that big and it had two mother-of-pearl handles and the grip here was gold. Now pick up on this. The grip was gold, you know? And the sword was gold, gold, fourteen-carat plate gold, you hip to it? And the rest of the sissy— this is all one piece now, see, the rest of the sissy bar was chrome. So I had it gold-plated and then they painted the sword with some kind of bullshit, you know what I mean? And the rest was chrome-plated. And this was all one piece, you hip to it? Gold and chrome together. And that blew caps there.

STATEMENT

BOBBY GOODPASTER Age Sixteen. Motorcycle racer

Some guy came in and bought a new bike and traded off his old bike and it was in a basket. It was a 175 Harley, all taken apart, completely. And he says, you can have that if you put it together. It was all in a basket, so I took it. Well,

it took me half a year to get it together, but I got it all together all by myself. He didn't help me a bit. I did every bit of it and I got it running and I used to ride up here all over the place and then he sold it, you know. I was crying and everything and he says, well, I'll get you another one pretty soon. So he got me a mini-bike, automatic clutch and everything. Boy I really thought I was something with that thing. You know the wheels are about this wide and I could do wheelies with it and everything. I'd rev it up and drop the back wheel and it pops up like that. So I used to do all kinds of stuff with that. Right across the street it's all woods. Nothing lives across the street—bunch of woods and a big old field. I went out there with this cycle, me and my buddy, and we cut down weeds and weeds for about a week and finally we had a path about this wide, winding all over the place. And we thought we was something. And I dug a hole for a jump, way down in the hole, and you could jump back up and everything. And that's how I learned to ride, riding around in that thing there. You'd be surprised how good I rode. When I first started out I could barely turn the throttle around to get it on and by the time I was ten years old I had it wide open, all the way wide open. Then I sold that thing and I didn't have another bike till I was about twelve. I used to ride another guy's bike, just mess around and everything. By that time I got to be a pretty good rider, riding in the woods and everything, so he bought me this Bridgestone 90. And the first time we got it—he brought it home one night, he got home around ten o'clock and I stayed up all night putting the bike together. It was brand new out of a crate. So got it all together. He wouldn't let us ride yet, you know, we had to get the battery charged and a whole bunch of stuff like that. Finally we got it all ready. I came home from school one day and my brother was riding his around. We both got one, same thing, same day and everything. So I started riding around with that. We went back out there in the woods and made that path better. I learned how 'do just about anything on a bike, you know, real good. Then finally he says, well, I'll let you guys start racing, this was the beginning of last year. And so I stripped it all down. I did all my own work on it, my dad's never laid a hand on any of my bikes, you know, he tells me if you're going to ride you're going to race, you're going to do all your own work. Says that's the only way you'll know what happens— if something breaks in a race you'll know what it is. You'll know how to fix it so it wouldn't happen next time. So I do all my own work on it. I stripped it all down and everything, but my brother, he didn't care too much about it.

I remember my very first race I won. That was really something. It was all mud, all real muddy, and I was used to riding in the real rough stuff. Actually it was sheer luck. I was going real slow, you know, just taking it easy, everyone else was going real fast and falling. And I'm the only one didn't fall. You know, I think I fell two times, everyone else fell about six. So I won it, you know, Schererville. I rode my first five or six races right over there. That's where my brother busted his leg the second time we went out to race. We went out there and we was racing and I was ahead and he came up behind me and he passed me up and some guy came up behind me and he passed me up and some guy came up around the outside and he hit him as he got stuck in it. It was muddy and he passed me up and slowed down and so he got stuck. He got set to push it and the guy hit his leg,

busted his leg, so that tied him up for the summer, you know, he wouldn't ride nowhere.

Mom's getting sort of used to it now. You know, she wasn't too sure about us racing. She didn't want us to race at first. She didn't say nothing about it, but I know she didn't. The first time we raced she didn't go. And then the second time she went, my brother busted his leg and that really went over good with her. She was all shook up and everything. But I don't think she minds too much now, because she saw me racing, and I'm a pretty good rider. She knows it, so she don't worry about it much now. She's getting sort of shook up now though because I'm going into a new type of race. Saturday night, that's when I'm supposed to race. I don't know if I can or not, but they got a new type of race and this is short track. Just on an oval track. All flat and smooth, like glass is, and you can't use no brakes. They take all your brakes off your bike. It's no brakes and it's just the best driver. You go flying into a corner, you just gotta make a slide all the way around the corner. My dad, when he first started riding there, he busted his leg riding short track. He went around the corner, some guy came up, tucked into him and busted his leg in eighteen places. So I don't think she wants me to ride it. I said to her the other day that I was going to ride short track. The heck you are! But after the first time she won't care. She'll get used to it.

SQUIRRELY GIRL

KATHY

We got so many kids they go to that school over there that's for retarded. They got retarded classes there. They must be in just about ten blocks about twenty kids that go there and they all say that these kids are harmless. Yet I've come home at night with my ex-husband and we'd see this girl, Joan Walker, she's twenty-one now, out in the back, screwin' guys fifty, sixty years old. Her neighbors, my neighbors. The paint guy, right next to her own house. She used to come in my garage when all my ex-husband's boyfriends were here. And tell 'em what beautiful bodies they had. And she's so ugly you wouldn't believe it. She took a knife and carved Ray Rayner in her leg, upside down. So I says to her, if you're gonna do that why don't you do it the right way? When you walk around you can't read it. Then she used to come over to the house and she's telling us who she's been going to bed with. And she didn't make no money. She walks around with half no clothes on 'cause she can't afford 'em. So for two years I try talkin' to her, you know, straighten her out. Don't do this, Joan, they're only takin' advantage of you. What are you, nuts? and all this other baloney. She says, I'm afraid of them. They threaten me. So I says, well, if you're gonna do it, why don't you make money?

Really, it got to be where you couldn't help her. She says, how much, a dollar? Fifty cents? You know what they used to give her? A bottle of Pepsi-Cola, a package of Wrigley Spearmint gum. Yeah. And all you'd have to tell her was this. I'll introduce you to Bozo the Clown and Ray Rayner. 'Cause she loved Rayner, you know, or Bozo the Clown. Well, anyhow, I seen a letter from him that he wrote to her giving her back her stuffed animals and stuff. This girl, she went through so many different phases of life. First, she went with a teacher who's a lesbian, at Jones Commercial High School. And she showed my girlfriend and I letters that were in stamped envelopes and everything, written to her about how madly in love this woman teacher was with her. Then she got out of that and she started likin' Ray Rayner. So Ray Rayner was writin' her letters sayin' don't bother me, I know you're a nice person and this and that, you know? And then she started takin' knives and carvin' her arms up and layin' out on Addison Street, she fell in love with this bus driver. Joe the bus driver. And she'd lay out on Addison Street when his bus would come and wouldn't let it go past. The guy was married and everything. So you know what happened? The guys used to make fun out of her. Of all the guys in the neighborhood none of 'em ever touched her 'cause they all knew that she was squirrely. So one night we're all sittin' on the front porch and she says this time, she says, you know, I'm still a virgin. Now these guys knew she's been in bed with umpteen thousand guys. And Sam says, oh yeah, how do you know? And she says, oh, I just know it. So Sam's sittin'—now this girl was twenty years old at the time, nineteen, twenty, well, he says, well, is your mother a virgin, too? And the girl looked up at him and she puts her hands on her hips and she says, now how in the hell am I supposed to know that? I don't sleep with my mother. Just like that, you know? And serious as hell. And she didn't like to talk about her mother. And she was serious. How the hell am I supposed to know, I don't sleep with my mother. There's a social worker down the street that tries to help her, you know. And then she had a baby. She got married to a guy named Horse. That really isn't his name, she just calls him Horse because he's built like a horse. So anyway, she comes here at night hidin' from him and she says, here comes Horse, here comes Horse, you know? And I said, where? My ma and dad were here, this was Thanksgivin'. And my dad's sittin' where Pete's sittin' and he had a TV snack table with a turkey leg and everything on it. And her and her husband comes in and watchin' my dad eat and he goes and grabs my dad's turkey leg. So he walks out of the house and old Joan goes behind him, Horsey, Horsey, wait for me, wait for me. She follows him right behind like in Japan. She'll walk ten feet behind him and at the same she's goin' "hi" to all the guys and lifting her skirt and stuff.

CHASE

FRANK JENNER Age Twenty-five. Ex-University of Chicago student.
Motorcycle racer

Hot summer evening. Rochester. Working nights, working overtime. But I didn't feel like working and this friend of mine came over with a six-pack. Country Club. It was a VW and I was gonna fix it. Got it in the shop and I couldn't figure out what was wrong with it. No one else wanted to tell me. So there we sat in the VW, up on the lift, floating around in the air drinking Country Club Malt Liquor with the radio playing full blast. And this is in the middle of the garage, like any big garage, like a big open assembly line. And everyone else was working and banging away and here we are, you know, having a party.

And we went out to get another six-pack on a Triumph 500 all hopped up. Got my fingers into it, played with it a little while till it was pretty snarly. We were running the little TT pipes and oversized main jet. Been tampering with it here and there. And so we're going down this little street, not bothering anybody at all. And just like tonight, there was that policeman standing there. And we stood there at the intersection just waiting for him to say something. I didn't even look off an' see that there was a fire up the block. So we waited about the approximate time of three stoplights or something like that and decided since he didn't give us any indication at all of what he wanted us to do we'd run along our own preconceived direction.

So as I was heading down there I realized it was a pretty good-sized fire.

Because all the people were on one side of the street with the equipment and the hoses ran across to the other side where the fire was. And I didn't want to go up into the crowd of people so I drove over the fire hoses, you know, the area of largest space.

As it turns out, the police commissioner was watching the fire in his red pajamas. And he had his motorcycle escort on either side of him and he was sitting back, reclining and watching the show going on. And this little bug disturbed him as he went by. He yells at his mounted policeman, after it, after it! And I was sitting there at the light and the guy on the back happens to work for Doyle Security— he's a part-time cop, you know. And he says, you better go now, you better go now. I was still ready to go over to the grocery store and pick up the beer, see. I had no idea that we'd antagonized everybody. I mean, I was just trying to mind my own business. I didn't even want anyone to notice me at all. And I was still going to park. But then when I heard the ole Harley-Davidsons start up behind me, man, I figured, well, maybe I'd better go. Then I decided to wait for the light to change anyway. Then finally I couldn't wait anymore, I had to go anyway. I couldn't wait for the light to change anymore.

Fortunately the first turn, the first good turn, I'd been practicing in sports cars. 'Cause what I used to do, like when I'd tune up a TR 4, if it couldn't do over a hundred, you know, easily, effortlessly,

I'd take it back in and tune it up some more. 'Cause that was my minimum standard requirement. And I'd go out and give it a good road test, I'd run, shit, I'd run twelve miles on the road test just to see if I'd done satisfactory work or not. And come back in and tinker with it some more. 'Cause that was my minimum stand— hairpin corner and with a passenger on the back—we went around pretty good on the Triumph. As it turns out, the Harley cops didn't even make the first corner. The one couldn't make it goes up over the curb. His crash helmet comes off and he spills the bike, man. And I didn't know this. I didn't know that I'd lost 'im already. And I was figuring, well, about two more minutes and we'll be on our own. We'll be out of the scene. I'll be with peace and comfort. I won't have to run anymore. But it didn't work out. 'Cause if I would have stopped right away I would've been all right. But as it worked out, I kept on going just a couple more minutes. And they had already radioed on ahead to the next town. And by this time I was already in the next town.

Then I ran into my first roadblock. There was just a single cop car at a four-way intersection and I came up on him about sixty-five or seventy. He jumped over to the window of the car and he was shaking his finger at me. And I rode up and I almost flew into the window. And we both looked by at him as I rode around him. And away we went down the road.

After a while we picked up a squad car that I just could not drop. I was really having my problems and I keep on turning around and watching as we wind through these nice hill roads. And the passenger says, don't worry about him, I'll watch him, just keep your eyes on the road. And this one car, a doctor out there, tried to force us off the road. This big ole Pontiac was coming down the wrong side of the road. And he was trying to do his patriotic duty by running the outlaw off. Here he is screaming down the wrong side of the road trying to force me into a ditch. It's a big green Pontiac versus a little Triumph 500, man, and plus that the squad is still on my back so I can't let up the throttle a bit, man, I mean I had nowhere to go but through that Pontiac. I couldn't make this clean break. You know. Everywhere I'd look I'd get cop car in my eyes. Except straight ahead. In fact, I ran straight into a dead end. And I had to turn around and come back, man.

One squad car blew a rod. We looked back and here's his car going *pshhhhhhh*, smoking, and just slowly falls off behind us. In the actual chase in their statistics they had twelve squads and two cycle cops after us. There were eight at the point of arrest. The only opportunity I had to get away from them I was in a straightaway and was flat out in fourth gear. I wasn't quite up to a hundred yet. And this big ole Ford was gaining on me in the straightaway 'cause it had more motor than I did. I was doing all right in the curves. Just then I saw a golf course. And it went by me at a hundred miles an hour. I never had a chance to slow down and go into it.

So I came up to a stop sign. And stopped. That blew the cops' mind. It was a lieutenant that was following me and I couldn't lose him. That blew his mind. He didn't even stop. He crashed right into me. He smashes the rear fender out, but fortunately, you know, I could tell at the last second he was going to crash so I had already gunned it again. So he crashes in the fender, but it doesn't quite hit the wheel and we go up in a wheely down East Avenue. In each gear I haven't

got time to shut off the throttle, so there are the two of us, going down East Avenue on a wheely. I just about get going in third gear and look up ahead and here are these three more county sheriff cars. Before there had only been the Brighton cops and the city cops. But now the third, the county black, big black county sheriff. And they're coming down the road three abreast. A flying wedge. I swear to God. And they're a whole bunch of 'em coming up on me from behind too, man. I hear the cycle cop off in the distance. And the curbs are too high to jump, you know. So it was a nice kind of residential area. I just said, this is it, went over and parked the bike and waited for 'em to catch up to me. I just couldn't stand it anymore. And there was this little Honda rider that had to go right up on the sidewalk, in the grass. And his jaw's kinda down like this, that this is what happened to bike riders. They took me off the bike and they had to park it. You see, East Avenue was blocked off both ways. They were sure they were going to catch me before I got out of the city. 'Cause they knew if I got out of the city they'd never see me, so they threw me up against the car. Of course I had the full beard, shoulder-length hair then, and little details like that, and my shades on. You know how I am when I'm road riding, man. I just am what I am. And this cop on the back is really stroky anyway. Like he's a pretty unusual specimen. I've met no other mentality like his.

Well, they were searching me up and down. One on each leg. Then they break me down like this and I go into the car. They put the handcuffs behind me so I can't do anything and some cop comes up from behind, of the crowd cops, and he comes up to me and says, oh, you're a beatnik, aren't you? And he goes like this, *crrrrrchhhh*, to the handcuffs, man. And I had a thumb I couldn't move for a week. From the way they put the handcuffs on, you know, a real act of sadism right there. In fact the cop that took me into the station told me how to hold my body. You know, you have to hold your body in a complete arch so your arms are separated in the air. In other words, you got to support yourself by your neck and your feet. So the handcuffs don't hurt you. 'Cause you're in a state of high physical pain and any jouncing at all and the handcuffs, well, like my thumb was out for a week and I took care of myself. I didn't fall on my arms or anything.

It was only nine charges. I got nine charges in ten minutes. Got thrown in jail, man. A long series of trials. Got some of the charges dropped and some of 'em didn't get dropped. See, they were really mad. Like the doctor that tried to force me off the road. He was going to come up and testify and say that I almost ran over the delicate children and things like that. And how I was a real terror and menace to the highway. And a hazard to the public safety and health. And coming from a doctor, man, they would've just stuck me in. If I would've tried to resist all the charges. Actually what happens is the cops and you work out a deal in the back room. If you want to. I mean, you can face the judges if you want to, but then you don't know what you're getting. But the judge will usually agree to whatever the two parties want to work out. Which is kind of a good thing to remember legally. 'Cause it works in Chicago for you, too. It's not always so obvious there 'cause it's a little more impersonalized there. But you still do it.

STATEMENT

COCKROACH Age Twenty-two. Ex-Chicago Outlaw. Presently employed as a policeman

When I was about fifteen years old my father bought me an Indian four-cylinder motorcycle. I fell down many times, hurt myself a few times but got to like it. I was clean until I hit the age of the about nineteen or twenty. I saw the motorcycle riders—filthy as pigs, you know, but they had a ball. I rode around by myself, knew nothing, figured maybe I'd get dirty. I like to be dirty. I'll go outa my way to put filth on my clothes, dirt on my pants, dirt on my face, mess up my hair and eat bugs. Bugs aren't really bad to eat. It's all in a person's mind. If you will eat a raw beef sandwich or you will eat a rare steak, a bug won't hurt you any more. A good grasshopper won't hurt you. It's nothing but meat. It's a delicacy, as a matter of fact. Myself, I prefer to eat 'em alive.

I saw you eat that piece of string before.

It wasn't as good as a bug, but it'll do, you know, for a snack.

A caterpillar, for instance, is a bitter son of a bitch. Yeah, very bitter. Flies are the same way. Grasshoppers. Cockroaches, beetles, other bugs you find around the house and waterbugs and stuff like that, they don't taste too bad. You chew it up, wash it down with a little beer. You never know the difference. People look at you, they think you're crazy. But if you don't think about it, it don't bother you. Next to eatin' cunt I would eat a bug.

THE RED VELVET DRESS

KATHY

They had a Halloween party up in Milwaukee. This girl had a red velvet dress and all I said to Funny Sonny was, boy, that dress would really look nice on me—I really liked it, you know? But I didn't—I only meant it was a nice dress. An hour later I had the dress in my arms. You know, and I says, like, where did I get this? They said, don't worry about it. This girl gave it to ya. I said, don't give me that bullshit. Well, here they pulled a train on this girl, up in the room. But she was willin', you know, she liked Sonny and this and that. So Sonny said, go try the dress on. And I went upstairs and I put the dress on and I came back downstairs to the Seaway. I showed it to Benny and he liked it. So I

went and sat over by the door as you go up and down the stairs and whole bunch of these guys came in from Milwaukee, came down from upstairs and they grabbed me and started bringin' me upstairs and I started screamin' and yellin'. Here somebody told them that the girl in the red velvet dress was the one that they were puttin' the make on. So I had the goddam dress on and they didn't know the girl was up in the bedroom and they started bringin' me up the stairs. And I'm screamin' and yellin' and hollerin'. Nobody's comin' to help me and these animals are sayin', oh, don't worry about a thing, we'll take care of you. Don't worry about a thing. Well, it just so happened that Sonny was walkin' outa the bedroom and he says, hey, man, what the hell youse guys doin'? They says, we're gonna cop ourselves our wings and shit, you know? Zip wasn't there. I met him at the Halloween party. When Zip first met me he didn't know that I was Benny's wife and he made a remark like, oh, a nice leeky c-u-n-t, you know. So Benny went up to him and said, oh, that's my wife. You know, like that. And he says, well, I don't care, she's still a nice leeky c-u-n-t. So anyway, Sonny comes outa the door and I'm cryin'. By this time, boy, I was really shook up. And I'm screamin' and cryin'. And Sonny says, hey, man, what the hell youse guys think you're doin'? They said, we're gettin' our red wings. Sonny said, not from her. Well, meantime,

Benny comes runnin' up the stairs, Johnny Davis is runnin' up right behind with half a dozen other guys and Benny's sayin', what's wrong? And I'm sittin' there cryin'. And they says, hey, we didn't know. They said the one in the red velvet dress and we thought it was your old lady. And I says to Benny, you know, all they woulda had to do was get me in that bedroom. And when they were done with me I think I woulda taken a gun. I woulda went in Eddie's drawer, 'cause it was in his room, and I woulda taken out his gun and I woulda popped my brains out. 'Cause I would never be able to face anybody if that ever happened to me. Even if it happened to me with two guys I wouldn't. And if Benny ever traded me off like he said he's gonna when he was goofin' around with Sonny. Sonny wouldn't even take me. He says to Benny, he says, what are you nuts? I would take a gun and even though I say that people that commit suicide have to be nuts, this is one time that I would go nuts. Because I couldn't take somethin' like that. Who would want you? Who'd even look at you, you know? Your own husband wouldn't look at ya if there was eight or nine guys on you. He wouldn't want no part of you. He'd only live with you for the sake of, you know, keeping everything righteous. And I've never seen 'em, really, take anybody that wasn't willin'. I never have. Except in Dayton. But our guys didn't do that.

RITA'S OLD MAN

CAL

Well, I thought I was pretty slick, see, 'cause I'm reverting back to my old days. Like in California, man, I carried heat on me all the time. I carried a 357 Magnum on me and when I went out on parties, you know, with my suit, with my $250 suit—you ever seen it? I got a beautiful suit. And it's been tailored, man, for a .45, but I carry a .38. Like you don't see a .38 at all, no folds or nothing. Like I carry heat all the time on me. Like I done in so many fuckin' people's heads and shit that I have to. And it was natural for me to go to the door with the gun when I'm in trouble. Or I suspect trouble, see. And like the dude's got a thing going against Rita, like he's gonna snuff her, see, as soon as he sees her. So O.K., I put my little gun in the doorway there and he comes in the door, man, like if I don't let him in he's gonna fuckin' force his way in with his little gun. And I don't know what kind of gun he's got. You hip to it? So I let him in, come on in, fuck it, she ain't here, you know, your old lady ain't here. And she ain't his old lady now, she's my old lady. She was upstairs. So anyhow, I was fuckin' around with this door, locking the door, like you would normally do, you know, it's four o'clock in the morning. Right? And so he's got some dude with him too. So he says, me and my buddy, we want to search the place. I said, you can search it. You don't need your buddy. You know like I'm playing slick. Fuck it, you ain't gonna need your buddy. So I'm lockin' the door on his buddy, his buddy can't come in too.

And it's dark, you know. And he walks in and he's walking straight up to her place. Anyhow, I let him in and goes through the scene, see, and he takes about six steps away from the door, no, maybe ten. And, like I pulled the .22 up, man, and I inject a shell into it, man, and I says, all right, put your hands where I can see 'em. And he puts his hands up and I say, all right, now come down here on the floor. Now there's all of Columbus, all over the floor, laying on sleeping bags and whatnot—you know how the couch used to sit sideways? That's the way it was, see. And he came back downstairs, you know, and everybody's snoring away. It's four o'clock in the morning. But they're waking up now. When I say put your hands up in the air all the people start to wake up. Like maybe the cops might be here. Funny how words like that wake you up. Anyhow, I say, lay face down with your hands out in front of you, face down on the floor, see. And as he's going down with his hands I put this gun behind his head, the rifle, man, and I followed him to the ground then, see? You know, he knew I was going to take care of business if he fucked up. So then I put my foot on his shoulder and kept the barrel at his head and I took his piece off him. What it ended up to be was a little fuckin' blank shooter, a little popgun. *Pop-pop-pop-pop.* That's all it can do. Anyhow, so I says, all right, I picked it up and I looked at it and I put it in my pocket. I let him up, you know what I mean? And then I said, all right now, what's your story?

You don't come in here with guns. 'Cause I'm salty about that, you know? So he says, I want to search the place. I want to see if my old lady's here. I said, your old lady ain't here. And so he started sniveling a little bit and I hit him in the fuckin' mouth with my rifle, man, like I hit the lieutenant colonel in the service. You remember that story run down to you? Well, I tipped him one good in the fuckin' mouth, man, and he goes to the floor, man, and I kick him about four or five times in the head. And Eddie's upstairs on the balcony tryin' to put his pants on. He's naked 'cause that's the way he sleeps. Stone naked. Just got his little earring, that's all. And he's hollering down the stairs and I'm fuckin' this dude up, you hip to it? And so I kick him in the head and Eddie comes down and bounces his head off the floor 'cause he's gonna get his in too. You know, he's half-owner of the coach house with me—well, anyhow, I says, now do you believe your old lady isn't here? And he says, well, how about lettin' me go? I says, man, like you ain't goin' nowhere. I captured you. You go when I feel like lettin' you go. In the meantime everybody's awake, Columbus and all of 'em. And so I hassle his mind for a few more minutes and fuck him up some more and he was hurting the next day—I saw him. Anyhow, he says, well, how about my gun, man? I says, I captured that too. Like you better get the fuck out this door, see, before I get fuckin' mad. And he starts to get up, starts to go. And I says, another thing, you're fuckin'

lucky that I wasn't mad. In other words, I told him you better get the fuck out of here before I was mad. I told him, you're lucky that I'm not mad. 'Cause he was. He was lucky I wasn't mad. 'Cause I woulda really fucked him up. And I fucked him up plenty. I probably fucked up quite a few of his teeth, man, 'cause it was all blood coming from the teeth and I put a fuckin' slice on his chin. He'll carry a scar, you know. I fucked him up plenty. I fucked him up as much as what a person would regularly do if he was mad. 'Cause I go stone mind when I get mad. I really do harm. Like I mighta even pulled the fuckin' trigger. Oh, and I injected a shell. You know, I was pissed off. When I took the gun off him I told him to roll over. You know, 'cause I was pissed off he had a fuckin' cap pistol on him. 'Cause I was gonna capture his gun and give it to Columbus, man, to take home with them. See, I thought it was a .38 or something. Something that they could play games with on targets or something. And he had a cap pistol. That pissed me off, see. So I ejected a shell. She's carrying a little .22 shell right now in her pocket. I ejected it right on his chest, *plunk*. And he looks down, clutches it, you know, like that's the one could have snuffed him. I ain't playin' no fuckin' games. I got real bullets. I'm runnin' this down to him. This is before I fucked him up, see. You know, I said, now give me that shell back. And he reaches up and gives me the shell. And I put it in my pocket—that's how she got it, going through my pockets.

ON FUNERALS

JOHNNY President, Chicago Outlaws. Transit truck driver

She was off and on, back and forth, she'd be with Paul and she'd be goin' out with Gene too. And so she was supposed to go out with Paul New Year's Eve and he called up one of the other guys in the club to go out with 'em, you know, they were supposed to go out as a foursome. And so on New Year's Eve she hadn't come home—it was I guess ten or eleven o'clock and she hadn't come home. And he called this Gary that was in the club that they were supposed to double-date with. He called him back and he said, well, Linda isn't here, he says, I don't guess she's comin'. He says, so you go ahead without me. And he proceeded to sit down. Now this is all according to what the police and the reporters and all people like that told me, things I picked up when I tried to get hold of 'em, tried to have the flowers delivered to his funeral. He sit down and he drawed her face all disfigured, you know, 'cause he was a commercial artist. He drawed her face all contorted, the way he saw her in his own mind, not the way she really was. How twisted and evil she actually was, which is the way he drew her on paper. And then he drew a picture of himself with a hole in his head and the blood runnin' down his face, in a frame of agony you might say. And then he shot himself. But he left notes for her hanging all over the house and everything and in the final note he says, "it's twelve-thirty, my darling, and you still aren't here. I can't wait any longer," or something like that. And he shot himself. And then they all proceeded to rob him blind, she went over

there and tried to get in the apartment and get all his stuff out, which she did get a big percentage of it. It was one of those rotten deals. She wasn't worth the trouble in the first place. The family had to buy her a wedding dress, I mean a dress for the funeral. She didn't have any clothes to amount to anything. What Paul had bought her—the police had impounded the whole apartment, you know. Most naturally.

She didn't have a black dress. So the family, being strict Catholics as they were, they decided to have a closed coffin funeral and a private funeral, see. Because of the disgrace of him killing himself. That's the way they look at it. To my own knowledge I thought it was kind of stupid, but that's the way they wanted it, so. We were trying to find out to send some flowers to him because I felt he was a club member and we always do and I didn't know if they'd accept him or not because it wasn't in the paper or anything about him getting killed. Just a little bitty article. Where he was going to be laid out or anything. I read the obituaries columns and nothing, so I finally called downtown to the city morgue. And they referred me to a funeral home, the funeral home referred me to somebody else and I got a big runaround until finally I found out the cemetery they were burying him in, out in Arlington, and finally I called up a florist and told him to send the flowers up there and he said they're not accepting flowers and I said send them anyway. I says, they can eat 'em if they don't want to accept 'em. I says it doesn't make any

difference to me. The idea is I want the flowers sent. So the guys chipped in for a big floral piece. I guess about four feet in diameter, a great huge floral piece like we buy for all the club members that do get killed or die, even if they're not in the club if they were in good standing when they quit. The club did the same thing for him like we did for Ted or Hap's wife. And neither one of these were in the club any longer, see, but we still bought the floral pieces for 'em. And in the same sense if they didn't accept it they didn't like the club, his family didn't like it at all, you see, because they didn't care nothing for motorcycles. Which was the whole thing. And Paul was kinda crazy about 'em, but they just didn't care nothing for it. And I guess they kinda held it against these people, my people, you might say, that he had killed himself. But actually one had nothing to do with the other.

Now you take Ted Singer that got killed on his motorcycle. Now this was an entirely different story. That his family was so nice to the guys that they came up and thanked each individual member, his father did. And I did not even know if the guys were welcome or not. But he was laid out, so I told all the guys, I said, well, hell, we're going anyway. All they can do is tell us we can't come in, you know. I said, if his father said that, we'll turn around and leave. I said, but at least we should, we have enough face to show up there. After all, the guy was a member. So we all went out there and his father and mother were the nicest people you'd want to meet. They said they'd been very sad if we hadn't shown up, if we didn't think no more of Ted than that. And he was from a very high-class family, too. They have a beautiful home out in Niles, the kid had all kinds of money. It was

just an accident. He had been out of the club for a couple of months. And the irony of that was it was on St. Christopher's Day when they have the motorcycle blessing. He was killed the same day. He went to the motorcycle blessing, came home and got killed.

They went out to a rock quarry after the blessing, you know, where we used to have picnics and things, where you can swim, along the road and they were all drag-racing out there. And one of the other guys that used to be in the club was sitting on the side road and Ted and another guy were drag-racing and he didn't see him and pulled out in front of him. And Ted hit him and then he swerved across the road and hit the cars that were parked there and the guy almost lost both his legs that he hit. The fact is I saw him about a year ago and haven't seen him since. But like I said, his mother and dad were—his dad took an interest. The difference in the two dads, the main thing that stands out is two people's fathers, Paul's and Ted's, were as different as night and day. Where Ted's father took an interest in his son's sports and loved the bikes because his son did, Paul's father hated the bikes because his son rode one. And this was the whole thing. But Ted's father helped him put his bike together. The one Carl rides, that's Ted's old bike. That beautiful 74 he's got, and the other one, is out of this world, they won't even sell it. It's just sitting in the basement just the way they put it together. They put it down in the basement and put it together, it's all chrome.

He told me it wasn't for sale, he didn't want to sell it. It's all chrome, there's not a wire showing anywhere. All the wires are run inside the frame. His dad made up special things for 'em because his dad was a tool and die maker, he made special

pieces for the bike and helped him customize it and everything—the whole difference is in how people look at things. Is either you take an interest in your children or you don't. I mean, to show you the big difference, where the one guy killed himself because he felt everybody was down on him, even his own parents. And the other guy he had everything to live for, but he died in an accident. But an accident's an accident, this you can understand. Having your own kid shoot his head off, that's too far out of sight, really. For a guy to do something like that he had to be very depressed. And the people around him must be depressing him.

ZIPCO IN THE ELMHURST HOSPITAL
ZIPCO, CAL AND PETE

CAL I wanted to take you home that night. Remember? Remember me and Eddie tried to talk you to go home with us?

ZIPCO I don't remember.

CAL Remember I was asking you, well, how's your speech? I was trying to figure out if you could talk right, see? Yeah, I'm talking all right. You said you were all right.

ZIPCO I was drunk.

CAL I know you was drunk. What I shoulda done—

ZIPCO What was I doin' up here anyways?

CAL I don't know what you were doing up here. You said you wanted to go ride your bike.

ZIPCO I was with Skip and the Renegades, wasn't I?

CAL Yeah. Skip and all those people.

PETE What were you doing in this area?

ZIPCO I don't know. That's what I mean. I was following those guys I guess, huh? I don't remember nothin'. I was ridin' down the road and all of a sudden—

CAL Ole Trego, Trego was all messed up, too.

ZIPCO I heard.

CAL He's walking all right now, you know. He was all banged up.

PETE Was he on the back?

CAL Yeah, he was on the back.

ZIPCO He went over, I guess he went over my head. That's what whatchacallit said. He looked back and he sees Trego flyin' through the air. He hit a metal pole or somethin'.

ZIPCO Hey, I got a little bit finally. You guys came through.

CAL We've been pretty busy. We haven't had transportation. Remember, I didn't have a car.

ZIPCO Yeah. They're always busy at the coach house.

CAL I got a Volkswagen now, see. I put twenty-five cents' worth of gas in it and I come up here.

ZIPCO Why didn't you bring some beer?

CAL We brought wine.

ZIPCO The wine is hot. How's it taste to you? *Hack.* I guess it's all right.

CAL It's better than water.

PETE So when did you find out that you had had an accident?

ZIPCO I was drunker 'n hell. I was cursing these guys out. You shoulda seen the cool names I give 'em for my name over there, you know. Give 'em some phoney name, you know, different addresses and everything. And then the cops I think stole my wallet.

CAL No. I got your wallet. A little brown wallet. I got it.

ZIPCO Yeah.

CAL I got your wallet.

ZIPCO How come you got it?

CAL It was given to me. To take care of.

ZIPCO Who?

CAL I don't know who gave it to me. Skip, I think, gave it to me.

ZIPCO Oh.

CAL So I got your wallet. I'm taking care of it. There's nothin' in it. Ain't no money.

ZIPCO License is in it, ain't it?

CAL Yeah. Is it?

ZIPCO Is it?

CAL I don't know. I didn't look. I didn't look in the wallet.

ZIPCO Yeah. Well, you said there's no money in it. Ah. Ha. Ha. Ha.

CAL I'll bring it up to you. I forgot it. Next time I come up.

ZIPCO Yeah. Ha.

PETE Is that you? Martin Jergins?

ZIPCO Yeah. That's me. Mister. Notice that. Mister.

CAL That's too bad.

ZIPCO I thought I could get away without payin'. See how long I could stay in this dump without payin'. And then I find out that I got insurance. My old man got insurance. They were gonna throw me out of here last week. They kept comin' up here and phonin' the credits, you know. Says, ah, you got insurance? Yeah. Yeah. I got insurance. It's comin'. It's comin'. And the doctor says, I think I'll have to let you go outta here. Seein' you ain't got no money. Ah. Shot.

PETE Were you lying in the road, or what?

ZIPCO I don't know. I don't remember. I don't even know where I was goin'. I don't remember nothin'. I remember goin' off the road. That's what I remember. Oop. Here we go.

CAL *Zzzzzap.*

ZIPCO I didn't conk out or nothin'. I didn't pass out. But I was, that wine musta hit me in the last part there. Real good, you know. I don't remember too much when I get loaded. I can remember givin' the cops a hard time. When they brought me out here, you know. So the nurse says, quiet, the little kid over there, you know. *Hack.*

CAL Hey, you want us to bring you a gallon of wine? Where you gonna put it?

ZIPCO You can't bring me a gallon. You gotta bring me little bottles.

CAL Little bottles. What kind you like?

ZIPCO I don't know. I like Thunderbird.

CAL Thunderbird?

ZIPCO Yeah. That's my brand.

CAL How 'bout Mogan David Concord. You like that?

ZIPCO Oh, well, any kind. You know what my brand is.

CAL What is your brand, Thunderbird?

ZIPCO Thunderbird. Yeah.

CAL You drive a Thunderbird too?

ZIPCO Yeah. Yeah. Hey, you guys know that Seaway's the last night tonight? They're gonna burn it. Hey, they're

gonna lock Vince in the basement and take everything outta there and drink up all his liquor and booze and beer and tip the bar over and burn the place down. It's his last night there, you know. Twelve o'clock his license runs out. They're gonna have a meeting. Hey, you ought to go up there. That's gonna be it. That's gonna be it. End of an era.

CAL This is the end of Seaway to-night. They took his license away.

ZIPCO End of an era, boys. No more.

CAL I hate to see it go too, 'cause the Seaway was a good place, hey. We had a lot of good times there.

ZIPCO The club's lookin' for other places. They ain't like Chicago. Go find a thousand-dollar beer joint. Stop and Go, fifty cents a bottle, or what is it, sixty maybe, for a beer. Dry yourself up, hey. Run outta breath runnin' across the street there for the wine. The only thing that saved me that night was that place across the street there. That wine.

CAL Yeah. He didn't drink none of the beer at the Stoplight. He was going across the street and buying bottles of wine. Isn't that right?

ZIPCO I wasn't buyin' it, somebody else was. No money. *Hack*. This is nice and hot and warm. The way I like it. Warm wine.

PETE Cal thinks we shouldn't go to races.

CAL We oughta go places where we—

ZIPCO Hey, you gotta show yourself though. You can't just go and hide in the woods.

CAL No. Not hide in the woods. Go to a big lake, you know, or camping area.

ZIPCO Yeah. But not all the time.

CAL You show yourself. You show yourself when you're riding through as a big group. Hey, there was three hundred bikes this last time, man.

ZIPCO Couldn't have been.

CAL Sure.

PETE A hundred fourteen, by count. And that's a lot, man. 'Cause there's cars and two guys on every bike. By my count a hundred fourteen. And that's just on going from Dayton to Columbus. 'Cause I know, my bike fell out, a lot of bikes fell out. Guys straggled. But we had in one pack, all with Outlaw patches on. That's a lot.

ZIPCO Looked good, huh?

PETE It looked beautiful. It stretched a long way down the expressway. And we had a police escort and people in Chevys and Cadillacs, they had to pull over to the side of the road and let by this group of hairy beasts. Right? Running all the lights. Running every light for sixty miles. We stopped for gas, man. What a scene at those gas stations.

ZIPCO That's what that girl was sayin'. You had more fun at the gas station than you had at the race.

CAL I'm hip.

ZIPCO Said that the Columbus race was shot.

PETE 'Cept I had to come back in the trunk of a car.

CAL Yeah, everybody pays two dollars to go in and see the race.

PETE We must have blown a hundred bucks like that, at least.

CAL I didn't even see the guy go round once on the racetrack. Why pay two dollars? I'd rather go someplace and spend two dollars on wine or something.

ZIPCO Yeah, well, you know. Sounds like a good idea, but you gotta make a couple of 'em anyway a year, hey.

CAL Yeah, like Springfield. That's the

big one. Hey, at least you're behaving yourself here.

PETE Who pays for a scene like this? It must cost a fortune.

ZIPCO My insurance. You didn't hear what I said. I was gonna see if I could stay as long as I can in here, but then the old man come crawlin' around and says I got insurance. Its twenty-three dollars a day here, or one, or something like that.

CAL How long they gonna keep you?

ZIPCO I don't know. The quack doctor, he don't know. Practicing, you know. His name is McQuack. Original Quack. Yeah, yeah. True. Comes in here, *himm, haaa, himm,* and he walks out. Hey, every day, *himm, haaa.*

CAL Hey, how the girlies here?

ZIPCO They got one good one for every ten.

CAL You oughta talk one of 'em into giving you some head.

ZIPCO A skull job. Hey, I can't find my dick anywhere. That's right. It's pushed all back into my belly.

CAL Oh, yeah?

ZIPCO Balls and all. Hey, what?

CAL You shoulda come home with us and you wouldn't be here. Next time maybe you'll listen.

ZIPCO You should grab me by the head if I'm really stewed out. I usually crawl underneath the bike when I'm really drunk, you know. I never rode my bike when I was drunk.

CAL Don't pay.

ZIPCO Yeah. I can't. I can't make it. See, I was tryin' to catch up to 'em, you know. An' all of a sudden they turn off, you know, I'm goin'. I just turned it on, you know. Turned it on, all of a sudden they go off, so I turned off too. I was goin' eighty. They were goin' about forty. *Kaplump.* Right into that

metal deal or whatever it was. The guys say, if I had been fourteen inches over I would've missed it altogether. But I glanced off it somehow. If I would've hit it head-on I coulda been dead.

CAL You hit the end of it.

ZIPCO I don't know what I hit actually.

CAL I seen it. I picked up your bike the next morning.

ZIPCO You got the seat, huh?

CAL No. The seat somebody got.

ZIPCO Yeah, yeah.

CAL No. Somebody stole it.

ZIPCO Yeah, yeah.

CAL When we picked up your bike there was no seat there. Somebody else picked up the seat. A passerby.

ZIPCO Ahh, you guys. By the time I get back to that coach house you know what's gonna be there? One stripted bolt. Right? Am I right?

PETE How's the food?

ZIPCO I'm gainin' weight, I think, hey. Instead of starvin' over there where you're livin'. He says I'm anemic. Livin' over there, I think, I got weak. My blood, my blood's bad. That's why you guys got to keep the wine comin'. Build up my blood count. Hey, it's way down. That's right. See how pale I am. Look at 'em feet. White. Pale. No color.

CAL That's too bad.

ZIPCO You're the first guys in a long time. I think it was three days ago I got booze.

CAL Everybody was gone, you know.

ZIPCO Carl and Joey and 'em come up here and got me some good stuff. Six-pack, wine. They come up here at ten o'clock, you know. Closin' time. Closin' time's at eight. Fuckers crawled up the elevator and they come in here, handin' me the six-pack. Throws it under here, under my sheets. After, they give me the wine, you know, and the nurse

grabbed it. We got it, you can't have that. You can't handle it. What are you guys doin' up here? What are you doin' in here? So they all walked out. Gerry, he got the bottle back somehow on the way out and he comes runnin' back in here to give it to me. Slips it under the sheets. I was drinkin' that beer and I got to the last can and I put it in the can there. Stupid nurse, just as I finished drinkin'. I even spilt a drink on me, just then the nurse walks in. Wanders around the room a little bit and he comes over here. Smells it, there was only a little bit left in the last can though. Had it all done anyway. But then later on they switched nurses or something, they was looking for toilet paper or somethin' and they found all the empties. So then they got in here and got the wine.

CAL You oughta hide it somewhere.

ZIPCO I got drawer number one. See that drawer number one? Under them rags. But I can't get over there.

CAL Get somebody to help you.

ZIPCO That one over there? He's a cool bitch. He gets high by himself. Yesterday. Big bottle of scotch, bottle of whiskey. Finished that bottle of whiskey last night. Working on the scotch now.

CAL You don't like scotch?

ZIPCO I drink anything.

CAL But you don't like it. I remember I tried to give you some one time.

ZIPCO I don't like that stuff. Don't taste good.

PETE Your bike. I saw someone working on it today.

ZIPCO Pulling stuff off of it, I suppose, huh? Hey, when I get back I bet you I find a stripted bolt. You know. Not even a good one. Just one stripted one. Right? Just a bolt. No threads on it.

CAL You should see your front end. The whole bike, it's a total loss. The bike is a total loss.

ZIPCO Them other guys says it looks pretty good, from Milwaukee. Don't look that bad, just the front.

CAL The front. The engine is sittin' there a little sideways. You know, if you take a good look.

ZIPCO What, did you look at it?

CAL Yeah. I looked at the whole bike. It's at the coach house.

ZIPCO Well, did you look at it? I mean, the frame bent?

CAL Everything. The engine's sittin' in the frame a little bit sideways, see. And your carburetor's tore right off. You know, it's loose. All your pipes are just smashed inside. Your front end is completely. Your tanks all dented up. The whole bike is a total. The only thing you can fix—

ZIPCO I got theft insurance.

CAL Yeah. The only thing you can, you do?

ZIPCO No I don't. I ain't got it.

CAL But anyhow, the only good thing—

ZIPCO I got it, but if I tell you that then it's gone. Right?

CAL Not till you get out of the hospital. Anyhow, the only thing good on your bike is your rear fender and you rear wheel.

ZIPCO The engine's good.

CAL No. The cases are broke on the engine. See, those guys didn't take a good look at it. I did 'cause I picked the bike up.

ZIPCO The cases are broke?

CAL The cases are broke. You look underneath the bike, you know. The cases are broke.

ZIPCO Huh, *arch, cough, hack.* They're broke right under there?

CAL Cracked.

ZIPCO Jesus Christ. It's shot. The trans maybe good?

CAL No. That's what broke the cases. See, when you hit the guardrail, you know where the shaft that goes to the trans, hey? It just smashed it right off. You understand? Like it goes inside the cases like that and it cracked your cases right across. Look underneath the bike.

ZIPCO Well, what about the other one, ain't they got front and rear?

CAL All one piece. Front and rear is all one piece.

ZIPCO Stolen bike. I'll report it stolen. I gotta report it stolen in Milwaukee 'cause I think that insurance is only good in Milwaukee. I mean Wisconsin anyways.

CAL Something like that.

ZIPCO Yeah. The cylinders are good?

CAL Yeah. The cylinders and the heads.

ZIPCO Wonder why it didn't burn?

CAL I don't know.

ZIPCO Shoulda burned right there on the spot. Usually when I fall down they always start on fire, this one didn't burn at all. Cheap gas in Chicago. Lousy state. Lousy town. Shot. *Hack.*

CAL When you get out you gonna go to the Stoplight and get your head bashed in again? You think? It's funny they don't have your leg in a cast.

ZIPCO No. They got to wait till its swelling goes down. It's not good enough to be in a cast.

ZIPCO What 'ya have in that bottle there? You gave me some poison, huh, now I might kick off. The whole bike's wrecked, one guy says it's all wrecked, the other guy says there's nothing wrong with it but a bent fork.

CAL I'll take a picture of it and bring it back to you. O.K.? I'll take a bunch of pictures and bring 'em to you. That way you'll get a good look at your own bike.

ZIPCO With what? You ain't got no money.

CAL I'll scrounge. I'll get my old lady to go out and hustle. That was my old lady that just come up.

ZIPCO Yeah. She looked kinda weak and peaked. Worn out. Musta been hard for her, huh?

CAL For an hour this morning. I was looking at my watch.

ZIPCO I thought you guys just got back this morning.

CAL No, last night.

ZIPCO Long trip. Crawlin' in trunks.

CAL No, we went in my Volkswagen. We had six of us in my Volkswagen. Hot trip.

ZIPCO Yeah, they say that. Looked like the retreat from Moscow. Napoleon's retreat all the way back. Miserable.

CAL Was miserable, man. Sonny didn't have no lights.

ZIPCO That asshole's gonna pay for that generator. I ain't givin' it to him. Hey, I ain't got nothin' from nobody that I didn't have to pay for. Not from Pig or anybody. I paid two hundred bucks for that stupid chopper there. Junk. Dirty '48 Harley Seventy-four. Two hundred bucks.

CAL Well, you got a deal.

ZIPCO Yeah. There's a guy down there says he's getting an army deal. You gotta buy twenty-five motorcycles from the army and they cost twenty-five bucks a piece.

CAL Yeah. But they're Harley-Davidson Forty-fives.

ZIPCO He says they're Seventy-fours.

CAL He's wrong.

ZIPCO Yeah. I know that. I told him that he's wrong. But he says he's positive

they're Seventy-fours.

CAL You know why? You know how I know? 'Cause the army never had Seventy-fours.

ZIPCO That's what I thought.

CAL They all had Forty-fives.

ZIPCO He says he's positive. He's completely positive. That's the one with the bird in the wheel. It's this guy that was ridin' down the street. Did I tell you? The guy wiped out his Sixty-four hog. He was ridin' down the street, fifty miles an hour, an' a bird flew right in his front wheel an' he wiped it all out. Three o'clock in the morning I think it was. Dumbo the pink elephant flew in the wheel, hey. He says next day they turned his wheel an' out flew a big old pheasant, or something fell out.

CAL At least you showed a little class an' hit a guardrail.

ZIPCO There's another guy here. Had a Honda Fifty or something like that. Getting off his bike and he falls down on the ground and breaks his arm. Had it stopped and the kickstand down, breaks his arm. Here's another bike guy here. A Honda Scrambler. Somebody cut in front of him an' he went underneath. Some college pinko or something. Short pants boy. You know how those pipes are. Burned his leg all to hell. Had a skin graft and stuff like that.

CAL You know one of the guys from Dayton got it the day before yesterday. Slammed right into the side of a car, man. Think maybe he broke his back.

ZIPCO That true?

CAL Remember this guy named Younger? Short cat, skinny, from Dayton. Broke his arm, back and leg. Slammed right into the side of a car. He was really burning on. He put thirty-five feet of skid marks. The car was turned almost sideways in the middle of the road.

ZIPCO Why didn't he go off the road?

CAL He was doing eighty miles an hour. I was two hundred feet behind him.

ZIPCO You pick him up?

CAL I picked the bike up off him.

ZIPCO Took his wallet to see what his name was, huh? Take the money out first, then check his name.

CAL No. It was a bunch of us, see. We were all in a group. Skip was there. Another time Skip was along an' Skip didn't get it.

ZIPCO It's all his fault, that fat fucker. Musta been his fault I smashed up, too.

CAL I don't think I'm going to ride with Skip. Everytime something happens he's along. But anyway, it doesn't pay to fuck around. It doesn't pay, there'll always be one that gets you. It's that one that comes out, that will come out of nowhere. That's the one that gets you. The one that comes out of nowhere. Suddenly it's there and there's nothing you can do. You know what I mean? Just burn when it's safe to go. In town man, just cool it. It just don't pay.